UNTANGLE YOUR EMOTIONS

DISCOVER HOW GOD MADE YOU TO FEEL

A SIX-SESSION BIBLE STUDY

JENNIE ALLEN

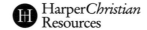
Harper*Christian*
Resources

Untangle Your Emotions Bible Study Guide

©2024 by Jennie Allen

Published in Grand Rapids, Michigan, by HarperChristian Resources. HarperChristian Resources is a registered trademark of HarperCollins Christian Publishing, Inc.

Requests for information should be sent to customercare@harpercollins.com.

ISBN 978-0-310-17145-4 (softcover)
ISBN 978-0-310-17146-1 (ebook)

All Scripture quotations, unless otherwise noted, are taken from the ESV® Bible (The Holy Bible, English Standard Version®). Copyright © 2001 by Crossway, a publishing ministry of Good News Publishers. Used by permission. All rights reserved.

Scripture quotations marked NIV are taken from The Holy Bible, New International Version®, NIV®. Copyright © 1973, 1978, 1984, 2011 by Biblica, Inc.® Used by permission of Zondervan. All rights reserved worldwide. www.Zondervan.com. The "NIV" and "New International Version" are trademarks registered in the United States Patent and Trademark Office by Biblica, Inc.®

Scripture quotations marked KJV are taken from the King James Version. Public domain.

Scripture quotation marked NKJV is taken from the New King James Version®. Copyright © 1982 by Thomas Nelson. Used by permission. All rights reserved.

Any internet addresses (websites, blogs, etc.) and telephone numbers in this study guide are offered as a resource. They are not intended in any way to be or imply an endorsement by HarperChristian Resources, nor does HarperChristian Resources vouch for the content of these sites and numbers for the life of this study guide.

HarperChristian Resources titles may be purchased in bulk for church, business, fundraising, or ministry use. For information, please e-mail ResourceSpecialist@ChurchSource.com.

First Printing December 2023 / Printed in the United States of America

CONTENTS

> *What do you hope to get out of this study?*

GET HONEST

This may be a little awkward, and it will feel a bit uncomfortable, but it will be worth it. We will be dealing with touchy subjects, and calling up some feelings that may have lain dormant for a long time. But God gave you feelings on purpose, with purpose. He intends for you to respond to your feelings. Until we start living in His purpose for our feelings and emotions, we will miss the real, rich experience of life He intends for us. If you feel all tangled up emotionally, are you also willing to consider a way out, even if it takes some time and effort? Be compassionate with yourself and get honest with God. He knows all of it already, anyway.

ENGAGE WITH YOUR SMALL GROUP

An important part of untangling our emotions is a willingness to do it with the help of others. I know it can be scary, but I'm going to ask you to be vulnerable and acknowledge the connection developing with those who are vulnerable with you, too. Try to listen and speak without judgment. Keep your group a safe and confidential place to wrestle and discover, a place filled with truth. John describes Christ as being "full of grace and truth" (John 1:14). I pray that this is how your small group will be described.

"And you shall know the truth, and the truth shall make you free" (John 8:32 NKJV).

COMMIT TO BEING CONSISTENT AND PRESENT

Every time you gather with your group, you will be building new skills for living healthfully with your emotions and learning how God feels. Consistency and presence show respect to God and those around you in this process. Arrange your schedule so you don't miss any part of this journey. Have your projects finished when you come to the group meeting (except the first one, which we'll do together).

Let every person be quick to hear, slow to speak (James 1:19).

GROUND RULES FOR GROUP DISCUSSION TIME

BE CONCISE.

Share your answers to the questions while protecting others' time for sharing. Be thoughtful and try to respond to "I feel" statements with another "I feel" statement. *Do not judge or condemn other people's feelings.* Don't be afraid to share with the group but try not to dominate the conversation.

KEEP GROUP MEMBERS' STORIES CONFIDENTIAL.

Many things your group members share are things they are choosing to share with *you*, not with your husband or other friends. Protect each other by not allowing anything shared in the group to leave the group.

RELY ON SCRIPTURE FOR TRUTH.

We are prone to use conventional, worldly wisdom as truth. While there is value in that, this is not the place. If you feel led to respond, please only respond with God's truth and Word, not "advice."

NO COUNSELING.

Protect the group by not directing all attention on solving one person's problem. This is the place for confessing and discovery and applying truth together as a group. Don't be afraid to ask for help. Your group leader will be able to direct you to more help outside the group time if you need it.

STUDY DESIGN

In the first meeting, your group's study guides will be passed out and you will work through Session One together. After that, each session in the study guide is meant to be completed on your own during the week before coming to the group meeting. Each week begins with a short intro before moving into the portion marked Study. The Study portion is followed by four application Projects, then closing thoughts from me. The study portion and projects can be completed in one sitting or broken up into smaller parts throughout the week depending on your needs.

These lessons may feel very different from studies you have done in the past. They are very interactive. The beginning of each lesson will involve you, your Bible, and a pen. Work through the Scripture and listen to God's voice. Hear from Him. Each lesson will conclude with four projects that will allow God to further change your heart and life, and a final word from me. Don't feel like each lesson has to be finished in one sitting; take a few blocks of time throughout the week if you need to.

The goal of this study is to dig deep into God's plan for emotions and feelings, *and to deeply engage these things in your own heart*. Projects, stories, and Bible study all play a role in it. You may be drawing or journaling or interacting with others. At each group meeting you will discuss your experience in working through that week's lesson.

WHAT *UNTANGLE YOUR EMOTIONS* IS NOT

We are all products of messed-up environments. Even the best parents, spouses, and friends have emotional wounds and scars. The hurt from these relationships takes work to process, and there are many great resources your group leader can suggest that take you deeper into the wounds from your past. I believe in the wisdom of Christian counseling from a well-recommended, certified therapist, and there is a time and place for it. Christian counseling is a process I've gone through many times myself, and so have many of my loved ones. It has truly brought so much freedom to each of us.

I might joke that this study is "10,000 hours of free counseling," but honestly, it's not intended to be a substitute. If you feel counseling may benefit you through this process, I encourage you to give yourself a gift: speak to your doctor and look into a therapist for yourself.

"I will give you a new heart and put a new spirit in you; I will remove from you your heart of stone and give you a heart of flesh" (Ezekiel 36:26 NIV).

Nothing is more powerful than God getting bigger in our lives. He has the power to heal with a word. My goal as you walk through *Untangle Your Emotions* is that God would get bigger for you, realer for you, and that you would feel His compassion for what you're going through. And as He does, that you would see a new, richer, more authentic way to do life, led by His Spirit.

SESSION 1
INTRODUCTION

Pages 10–27 are intended for you to get acclimated
to this study on your own, after you watch the first
video. Flip to page 28 for Video Teaching.

One question I've never liked is, "How does that make you feel?"

Truth is, often I just don't know. Or I don't want to know.

My feelings are tangled. They feel unknowable, out of control, and sometimes, alarmingly absent. Maybe yours do, too. Feelings! What are we supposed to do with them? And what even are they anyway?

A lot of us might answer, *"Nothing I want to deal with, thank you very much."*

Why? I can tell you that personally, somewhere along the way, maybe from church, or just from growing up, I learned I wasn't supposed to feel feelings. Or be sad or angry or scared. I was supposed to be okay. Or maybe I avoided feelings because I despise the feeling of being out of control; I believed these feelings were too scary, and sitting in the hard felt … too hard.

Even now, as an adult, every time I experience sadness, fear, anger— emotions I've been conditioned to not want to feel—something deep within me automatically starts trying to fight off the feeling like it's a virus. I go on attack, judging that feeling, condemning it, and telling myself why I shouldn't feel it at all. My brain tells me how it is all going to be okay. It barks out all these orders about what I need to do so I can finally stop feeling the feeling.

Before we heal, though, we're going to have to dump some unhelpful notions that are baked into a lot of our hearts and minds. Most of us from our earliest days were taught to not feel what we feel.

Regardless of the year you were born, the city you grew up in, and who raised you, I am confident you were conditioned right from the start regarding what to do when you felt a feeling.

Most often, it's control yourself.

They might be embarrassed by our displays of emotion. They might feel judged by them. They might be emotionally unhealthy themselves.

For whatever reason, often accidentally, they shame us for feeling things. They dismiss the feelings we felt. They neglect or ignore altogether the emotions we are juggling. They shut down as we try to engage.

It's not just our parents. The church often doesn't know what to do with feelings either. And that can be deeply hurtful.

Listen: I so wish I could talk to you in person. What is your story here? Were you ever told by a parent or family member or some kind of spiritual authority not to feel something that you really and truly felt? Were you ever told to "calm down" because your natural reaction was too big?

We're going to take steps toward uncovering and healing those wounds in our time together.

And a huge part of that is recasting some of the unhelpful things we've learned in church.

Your feelings, my feelings, are not evil things that need to be beat back.

In fact, feelings *can't* be beat back. No matter how far down we stuff them, they pop out at funny times. And they get all over people—especially people we love.

Rage, fear of rejection, jealousy, bitterness, despair—if you're like me, you might think you packed all those things safely away in a box, so you won't

have to see them again. But those things sneak back up on us when we least expect them.

And they're not figments of our imaginations. Those feelings are tangled up with something *very real* in your past or present, something that absolutely IS a big deal to you, whether or not you're ready to admit it.

Feelings can't be beat back.

They can't be ignored or dismissed.

They are trying to tell us something.

Look. I'm a fixer at heart. For so long, I've considered my fix-it nature a gift—a spiritual gift, in fact. But over the past few years, as I've been on a journey toward untangling my emotions, I've come to see things in a very different light.

The truth is that I've been so busy fixing stuff that I've neglected the "feeling" part of me.

I haven't given myself permission to feel what I actually feel. I haven't given the people in my life permission to feel what they actually feel. It turns out you can't feel feelings while you're preoccupied with fixing them.

Crazy, right?

I bet you can relate. In fact, I know it. I bet you tend to resist examining your feelings, too.

As we go through these six weeks together, learning to listen to what our emotions are trying to tell us, I hope you'll discover this truth: ***Feelings were never meant to be fixed; feelings are meant to be felt.***

I know what you may be thinking . . . Let me take a minute to put some of you at ease. The world has swung so far that emotions are everything. That's not what I'm saying. We're talking about emotion that is submitted to the will of God and the truth of God's Word. We're not talking about just feeling things and acting on them everywhere. We're talking about using them for the purposes that God intended; our emotions connect us to each other and to God. But one reason that our feelings are coming out sideways everywhere is that we never learned how to do this right. And so, when we begin to heal, we begin to experience emotions how they're meant to be experienced. Then what happens? We start to regulate. It's a great word. It's a counseling word, but it's a spiritual word. It's what happens to our bodies. God built our nervous system.

Maybe you're like me, and you don't like what emotions do to you. If they are to blame for so much discomfort and pain, why would we give them license to come in and just do as they please?

I follow Jesus. And whether you follow Him too, or have no faith at all, or are still deciding what you believe, I'm glad you are here. If you don't know Him, I'm guessing that as you keep reading, you'll really like Him. Because as you will see, He is compassionate toward you, toward me. This matters because to be human is to long for compassion. We're all starving for compassion, and Jesus wants to provide it.

When Jesus walked the earth, story after story of His ministry confirmed how He cared about each person He came across. He cared about their mind. He cared about their body. He cared about their soul. He even cared about their emotions, which is something we don't hear too much about. You know, I've heard smart Bible people teach and preach on how important it is for us to believe certain things with our minds, behave certain ways with our

bodies, and commit to certain things so that our souls will spend eternity in the right place, but I can't think of a single time when I heard someone teach on how Jesus feels about the emotions we feel. Which is odd to me because all throughout Scripture, we see evidence of God the Father, God the Son, and God the Spirit feeling lots and lots of feelings.

How do you think God feels about your feelings?

Is He judging them? As I began my research on this, I had so many questions:

When does feeling an emotion turn sinful?

Have all the emotions always existed?

Will they exist forever in heaven?

What does God do with His emotions?

Wait, does God have emotions?

Does the Bible say we can control our emotions?

If we can, does that mean we should?

At the very least, I had to know, are my feelings sin?

Here's the thing though: our feelings are trying to tell us something important, not trying to take over. In fact, God gave them to us for a reason. Not to be controlled or "managed" but to *connect* us, to Him and to others around us. Are you prepared to believe that our feelings are actually a gift meant to help us? And that *all* of them are good?

GOD FEELS

Where do emotions come from? They were built into us by a God who feels. We were designed by God to feel.

Are you coming into this study with any questions or negative experiences as it relates to your emotions? If so, describe them.

Throughout this study, we're going to look at undeniable proof that God is a feeler—Father, Son, and Spirit, and that He not only has feelings, but expresses them, and responds to our feelings.

In this way, emotions are simply another facet of what it means to be made in the image of God. Therefore, **emotions are not bad; emotions are not sin**.

Emotions aren't even neutral.

Understood from the perspective of God having a purpose and plan for them, emotions are actually *good*—and not just some of them, like peace and joy, but all of them.

ALL EMOTIONS ARE GOOD

Hebrews 4:15 says of Jesus,

> "For we have not an high priest which cannot be touched with the feeling of our infirmities; but was in all points tempted like as we are, yet without sin" (KJV).

Aren't you just blown away by this?! A God who feels all the feelings and does not sin—He appropriates all those feelings rightly.

Jesus felt His emotions and allowed them to draw people to Himself—*and* didn't sin. Emotions are not the sin. It's what we do with them. We'll look at all of this during our time together.

In digging into the science of emotions over these past few years, I've become convinced that emotions are not meant to control us; they are meant to *inform* us. To alert us. To connect us. To remind us that we're alive and to help us make sense of the world around us.

WHAT IS THIS STUDY ALL ABOUT?

Together in this study, we're going to discover so much about the way our God feels, and the way His people interact with Him through feelings— the way they change, grow, and are led. **Read each of these verses and identify who feels the emotion, and what emotion they're feeling:**

Isaiah 53:3	
James 4:5–6	
Psalm 38	
1 Cor. 2:9–11	
Matthew 5:4	

In Psalm 51:6, the psalmist David wrote,

> "Behold, you delight in truth in the inward being, and you teach me wisdom in the secret heart."

This is what God wants for you: wisdom and truth. Not just in your brain, in your heart, and in your body, but *in your inward being*, healing your soul to the depth of who you are and why you're here.

God built us mind, body, and soul. He wrapped us in flesh and set us here at this time and in this space, and the mystery of what we feel and how we experience it all points to a God who not only built our emotions but feels every last one of them, too.

RESPOND

> *Coming into this study, how would you describe your relationship with your emotions?*

> *How would you describe the way you've always thought God felt about your emotions?*

THE 3 C'S

Through these six weeks, we're going to discover how we can engage directly with these emotions and take them to God. But there's another option: we can resist them, trying to evade what feels uncomfortable, embarrassing, maybe even painful. Most often, we choose the latter option. Mostly because we're afraid that if we engage directly, we'll crumble under the weight of our feelings. And can I tell you? That is *totally understandable.*

In fact, in certain seasons, it is flat out all we can do to make it through the day. We can't crumble, so we turn to what I call The Three C's:

1. **Cope:** We distract ourselves by turning to a favorite diversion for comfort or busyness.

2. **Conceal:** We stuff down that feeling and attempt to cover it up.

3. **Control:** We try our hardest to take charge of our situation or over others in the hopes of making everything a little more desirable, a little more manageable.

When we **cope**, we *cannot deal with how we feel,* so we go searching for an escape hatch instead. The list of coping mechanisms is nearly endless: procrastination, lethargy, drug use, indulging in unhealthy amounts of food or alcohol, oversleeping, self-harm, social isolation, workaholism, online shopping, obsessive-compulsive behaviors, and more. Of course, some of our coping mechanisms are, on the surface, innocuous. My two personal favorites are bingeing shows on Netflix and eating vast quantities of queso with my best friends. As enjoyable as those things are, the relief they bring is momentary; the distraction and satisfaction is always short-lived, especially if you never deal with the "thing beneath the thing."

When you **conceal**, you'd rather sit there quietly with all your emotions and feelings tucked inside than risk them coming out and facing the gravity and reality that awaits you. So, you stay hidden. You say you're "fine." Yet the more time that goes by, the more desperate, chaotic, and needy your realities become.

When you **control**, it looks good to everyone else! They think, "Wow—what a soldier. They just keep trooping on." You avoid your emotions. You tell yourself you should not feel this way. You do what you can to keep going, but in the end, you end up totally out of touch with reality. Again, sometimes you've just got to keep going. I get it. But this is not a long-term solution.

It's hard to unlearn the patterns that have been ingrained in us for all our lives. But if we choose the easiest paths every time, if we check out through controlling and coping and concealing, we miss the best parts of life. The parts we are craving.

There is a better way to respond to emotions: we fully embrace the purpose they were made for . . . connection. Connection to God and to others. This is where we're going next on our journey. And we simply cannot get there if we continue to control, conceal, and cope. We can opt for the fourth and absolute very best C: CONNECTION.

RESPOND

Take a minute alone and pray before you move ahead. Then take a few minutes before God and write out your answers to the questions below.

1. What's your go-to "C"?

2. How has it served you? Maybe more honestly, how's it been going in applying your preferred "C"?

3. Considering this, what do you hope most to get out of this time?

PROJECT 1
ROPES

When I first conceived of this book, an image came to mind. It was of a continuous, unbroken rope held taut in a triangular shape, anchored by figures standing at each of the three points: God, the people in our lives who love us, and us.

The rope was smooth from point to point, clean, unencumbered, straight. That rope represents our feelings and the way they are meant to work.

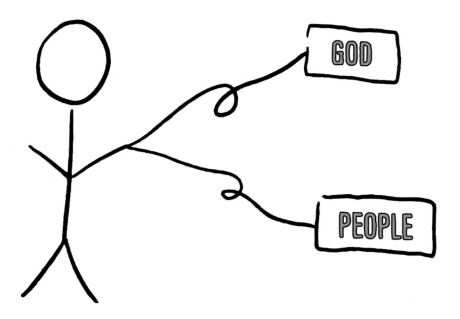

But that image contrasts starkly with how most of us would describe our emotional inner lives: a jumble of confusion that has us tangled up in knots.

See, here is how it feels in reality . . .

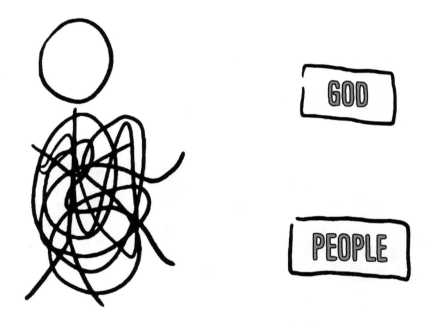

We want to connect all our feelings to God to get them worked out and we try to connect deeply with people, but it all feels like a mess.

PROJECT 2
FEELINGS ASSESSMENT

After you read each statement on the left, mark how you assess yourself on the accompanying scale to the right.

	NEVER	RARELY	OFTEN	ALWAYS
I pay attention to my body's physical cues during high-stress situations and conversations.				
I pay attention to my mind's thoughts during high-stress situations and conversations.				
I pay attention to my authentic feelings during high-stress situations and conversations.				
I trust myself to feel whatever it is I truly feel.				
I am unafraid to share how I feel with others.				
I am patient with myself regarding my emotional reality, even when it changes more frequently than I would prefer.				
I stay engaged with myself and others, even when things feel emotionally intense.				
I stay calm and centered, even when my emotional reality feels undesirable.				
I stay curious with myself regarding the emotional experiences that unfold.				
I remain grateful for emotions as they surface for me, even when they are ones I might not have chosen.				

CONCLUSION

Our emotions have a purpose, and that purpose is connecting us to God and each other.

In the past few years, I've been studying these tangled ropes of our emotions, and working out which moves are available to us to untangle them. And I can tell you that, friends, we can do something about this. My tangled ropes are now ropes pulling me toward God and the people I love. And it really is so much more of the abundant whole life Jesus promised we could have.

And I want this for you, too. Stop coping, controlling, and concealing it all, and let's see if the best parts of life don't show up when we vulnerably, bravely untangle that rope with our God and our people.

I want to break down in simple fashion what we actually can do when an emotional wave hits. When we don't know what to do. How can we break it down so that whether you feel a million huge waves a day crashing into your soul, or you wonder if your emotions aren't there because you haven't felt in so long, you would have something simple that helps anyone starting from any place to untangle it one step at a time.

The knots of our soul untangle with a few moves. And I am going to lead you through one every week.

Next week we'll start with **noticing** feelings.

Then we'll move on to **naming** our feelings.

Next, we'll talk about what it means to actually **feel** our feelings.

We'll take the daring chance of **sharing** our feelings.

And then we'll talk about the **choices** we can make, as we support our feelings with resources.

So, the process we will go through breaks down like this:

Notice

Name

Feel

Share

Choose

Five simple steps that may not feel simple at all. And while this process isn't what I would call "easy," these practices *will* help you live at ease a little more, day by day.

God is going to help you feel again in a healthy way, because that is what He wants.

Maybe you've realized that you don't really know God, that you don't actually have a personal relationship with Him, where you talk every day and you look to Him and live for Him. If that's the case, then before you go any further, read the "How to Find God" page in the back of this book. It'll be the best, most important thing you'll ever do.

Those of you who feel like you're overrun with emotion, I'm going to help you slow down and take each feeling apart and notice it and name it and know what to do with it. It feels ironic to apply order and a process to something as mysterious and organic as emotions. But God created in order and following a process. I am someone who appreciates order.

Let me remind you how valuable your feelings are. Let me prove to you how necessary they are to your vitality in relationship with God and with others. Let me lead you to a healthier experience of your feelings. Let me show you the moves—the twists, the passes, the neat limbo you can do over or under that pesky piece of emotional string—that will take you from "emotionally stuck" to emotional health, from apathetic to able to articulate what you feel, from distanced to connected to your own soul and others, and to a deeper and more robust connection with God. These are the byproducts of an emotionally healthy person.

Emotional health is possible. It is possible to untangle the knots that may have built up over decades in your life. I know it seems impossible. It's not. I've seen it happen for me and so many people I love. And it can be true for you, too.

"For we have not an high priest which cannot be touched with the feeling of our infirmities; but was in all points tempted like as we are, yet without sin" (Hebrews 4:15 KJV).

SEE ::

Watch video session one: **INTRODUCTION**

Use streaming instructions on inside cover or DVD.

Take notes if you like.

ASK ::

Use session one: **INTRODUCTION**
Conversation Cards for group discussion.

SESSION 2

NOTICE

Work through pages 33–50 on your own before your next group meeting and before you watch the next video teaching.

Recently I was driving in the late afternoon. I had just picked up groceries and was making plans about what to cook for dinner.

But I felt . . . off. My breath was short, and my chest felt tight. As I was trying to plan dinner, my mind kept racing—not to anything specific; just bouncing around like a ball. I was clearly having symptoms of anxiety, though I couldn't identify what exactly I was anxious about.

Where is this coming from? I didn't have any glaring stress in the day. I had started pretty content and had gotten a lot done. I couldn't remember any conflict I had experienced earlier.

While nothing of importance was "wrong" that day, it happened to fall inside a season of intense stress for me. My husband was going through a really hard time and needed support, and we had some worries about future and finances. So apparently, according to my body, figuring out dinner and running errands were not the humdrum routine they once had been. I was headed home to face difficult things and worrying for my husband. I was worried for our future.

My reserves were running low. Scary low, in fact.

These feelings were warning me. *We're reaching the end of our rope here.*

Listen, I'm great at stuffing my pain into a "box on the shelf," a skill that often serves us well in seasons of stress. I've got to function, right? If I let my difficulties run amok, how am I supposed to get anything done?

The thing is that only works for a time. Instead of staying quietly locked away, our emotions increasingly demand attention—in my case while mindlessly making a dry-cleaning run.

NOTICING CHANGES THINGS

I want a new scenario. I want to be more engaged in the process of untangling my emotions. So, let's imagine that instead of choosing to snap at my family or withdraw in this scene, *I notice what I'm feeling, and why.*

In *this* scenario, I walk into my house, I recognize the reality of my stressed family, and instead of snapping I say, "Hey. How about we sit down and talk about our days? I had a rough day. I have been worried about some things with Dad, and I almost just lost it in the car."

And then one kid says, "Ugh. Me, too."

And another kid says, "I had a bad day, too."

And my husband comes down, and we hug, and instead of pretending everything is fine, we all share what's going on with us. We sit down and eat, and we face the hard together. And it's messy, and it's right. The hard gets lighter as we carry it together.

Your emotions are trying to tell you something.

They're telling you specific things about your situation. They may be telling you that your reserves are lower than they've ever been. They may be telling you any number of important things. But before we can decipher what those things might be, **we have to notice them.**

Not brush them aside.

Not stuff them.

Not talk ourselves out of them.

So we're just going to take one little step together today toward connection through our feelings. Step one of connection through feelings: *Notice how you feel.*

AM I OKAY OR NOT OKAY?

Ask yourself one simple question: ***How am I feeling?***

If you're like me, sometimes you don't know how you're feeling.

But whatever unidentified emotions are swirling through you can probably be broken down into two categories:

Okay.

And, *Not Okay.*

Am I right? You can tell the difference if you take a moment to breathe.

NOTICING is simply saying, "I am experiencing some feelings."

There's probably a good reason you're experiencing these feelings. For now, notice, and invite God in. Then listen for what He has to say.

FEELINGS IN THE BODY

We talked last week about how God made us. God made our bodies, and He made them good. That means our feelings are good, too. That may go counter to a lot of things you've been told. But read this:

"For you formed my inward parts; you knitted me together in my mother's womb. I praise you, for I am fearfully and wonderfully made. Wonderful are your works; my soul knows it very well. My frame was not hidden from you, when I was being made in secret, intricately woven in the depths of the earth. Your eyes saw my unformed substance; in your book were written, every one of them, the days that were formed for me, when as yet there was none of them" (Psalm 139:13–16).

Your emotions are part of the way you were made in God's image. You were woven together with purpose.

God made your body in such a way that it can also tell you things about your emotions, which can tell you something's going on that needs your attention. But it can be hard to listen to your body because we are all so used to ignoring them.

The next time a feeling rises in you—in your body, in your brain, in your spirit, in your soul—I want you to stop what you're doing … just for a second, stop. *Notice* the feeling instead of brushing it aside; connect with it.

If it's helpful, ask yourself these two questions:

▶ **What do I sense in myself emotionally? Am I *Okay* or *Not Okay*?**

▶ **Can I sit with either reality for a bit?**

If you're at step one, having trouble determining whether you're *Okay* or *Not Okay*, tune in to your body for a minute and see if you find any clues. Our bodies are constantly feeding us information about how we're doing, but we have to notice the clues to learn from them.

So often we find that noticing and healing go together. God made it like that. And *noticing* is part of His character, through and through. From God the Father, to the Son, to the Holy Spirit. He's all about noticing emotions and healing people. When we're noticing, we're becoming like Him.

STUDY ::

Read Mark 5:21–34

RESPOND

▷ *In your own words summarize the story of the woman touching Jesus' cloak as told in Mark 5:21–34.*

▷ *What was the woman feeling when she reached out for Jesus?*

▷ *Why was she motivated to push through the crowd and the fear?*

▷ *What was Jesus on His way to do when the woman reached out for Him? Why, can you imagine from these verses, did Jesus choose to heal the woman in middle of the crowd?*

At some point, the woman with the issue of blood had to realize she was not "fine." Her health issue, in the culture of her day, made her "unclean," so she wasn't supposed to be out and about. But she had to have said to herself, *This is not okay. I am not okay.* She had to put aside **coping** with the problem however she had become accustomed to in the last twelve years. Put aside

concealing the problem by hiding away in her house. She had to release **control** of all the ways she had tried to heal that hadn't worked.

The woman had to notice what she needed and believe that Jesus could heal her. The remarkable thing about this woman to me is her bravery. She was brave enough to push through every barrier to reach Jesus and to be close to Him. It had to be nerve-wracking to elbow through the people in the crowd. These were the very people who shamed and condemned her for being in public at all. But the second she reached out and touched the edge of the cloak Jesus started to look for who it was. And it was in that moment that she came forward and their eyes met. Jesus noticed the woman in all her need and all her feelings and healed her. He then called her daughter. That's a relationship. It's a permanent, familial relationship that He wants with each of us, too.

Look—we need to be healed in our emotions. We need to notice what's happening—that there is loss in our lives and we're coping, concealing, or maybe controlling. I'm calling you to notice what you're feeling that requires healing outside your strength. Notice so you can be brave enough to ignore the awkwardness and reach out for Jesus. The second you do, when you reach out for Him, He is waiting. He is noticing you right back. He turns to you and He has the power to heal.

GOD THE FATHER: READ EXODUS 3:7–10

God the Father is a noticer, too. He is not removed from us. He notices, He cares, and He delivers His people. Let's look at one of the many ways He noticed the emotion of His children in Israel, and how their emotions connected them. In this passage, God is speaking to Moses through the burning bush.

What did God see?

What did God hear?

What was God concerned about?

How did God respond?

If God noticed the cry of the Israelites, He notices yours, too. Like the woman reached out to Jesus, like the Israelites cried out to God, we can connect to our Father when we notice we're not okay. And He answers.

> *What do the times God the Father and Jesus "noticed" reveal about the godhead? Their character? Their own emotions?*

> *If God felt that way for the woman with the blood, for Moses and the Israelites, is it hard to believe God feels that way for you?*

GOD'S COMPASSION

I'll confess that, despite all the work I've done these past three years, sometimes still **there's a part of me that feels all the messy things and there's another part of me judging that I feel all these messy things.** And I feel conflicting feelings, all at once! It's easier not to notice, because if I notice, I'll start judging.

That part of me that judges is the part of me that's wearing me out. God hasn't put that judgment on me; I put it on myself. And possibly, the enemy has helped.

Untangling our messy mass of emotions will require us to stop seeing feelings as unhelpful or even sinful, so that we can learn to steward them well. I want us to move from judging what we feel to just feeling it. We waste so much energy stuffing and keeping our feelings on the shelf rather than just feeling what we need to feel. We can change, I promise, but it will take time and intention.

IT WILL TAKE NOTICING.

The truth that sets us free begins wiht the truth that we are sad or hurting and desperately and urgently need help. There is no hope for health, joy, peace, and salvation apart from Jesus, the One who is all and has done all for us. He died on the cross for our sins. He was raised to new life again. He offers us grace and forgivensss and an eternity spent with Him. The Bible is clear that the truth of that sets us free in John 8.

WHO ARE YOU, LORD? & WHAT DO YOU WANT FROM ME?

Read: John 8:31–32. In light of what you read, answer the questions above.

DIGGING DEEPER

(OPTIONAL PROJECT FOR THOSE OF YOU WANTING TO GO DEEPER)

▷ *In Exodus 3:7–10, look up the Hebrew term for* see *or* seen. *Do a word study of how that is used throughout the Bible.*

▷ *What does it mean that God* sees *us experiencing our real emotions?*

PROJECT 1
ARE YOU OKAY OR NOT OKAY?

For this project, I will ask you to notice what's going on in your body, and what your body may be telling you. In your everyday life, you can do this while sitting still, going on walks, or having quiet time. Wherever you can settle in and begin to notice.

Here are some steps for doing this outside.

STEPS

> *Get outside somewhere that's grassy.*

> *Give yourself an hour, if possible.*

> *Don't take music.*

> *If the weather permits, take off your shoes and sit or stand in nature.*

> *Starting from your feet and moving up through your head, go through and notice every part of your body and what you are feeling.*

Remember: "I formed you in the womb I knew you, and before you were born I consecrated you" (Jeremiah 1:5). God made your body, and He made it good.

When God made man, here's how it went:

"Then the LORD God formed the man of dust from the ground and breathed into his nostrils the breath of life, and the man became a living creature" (Genesis 2:7).

You can be still before God and simply be.

PROJECT 2
REFLECT

▷ *Start a journal this week, where you reflect on the question,* Am I okay or not okay?

▷ *Make notes throughout the week of how you feel.* I'm not okay on Tuesday at 3pm, I am okay on Wednesday at 10am. *Note down the time and the day. Also possibly note what was going on.*

You could set a reminder on your phone or watch to keep you jotting things down every couple of hours. This will be revealing.

	MONDAY	TUESDAY	WEDNESDAY	THURSDAY	FRIDAY
8 AM					
12 PM					
3 PM					
8 PM					

PROJECT 3
REMEMBER

> *When you weren't okay as a child, reflect on what your parents made you feel. Did you feel comfortable expressing emotions? Or uncomfortable?*

> *Think of the first time you remember feeling scared. How old were you? Did anyone know that you felt scared? How did they respond? When you look back, how did that feel for you?*

*Note from Jennie: Some of you just wrote a really painful memory, and I just want to say I'm so sorry. I hope that you felt seen, soothed, and safe, but if you didn't, I just want to say I'm sorry.

When we remember the tender feelings we had as a child, it's important not to judge. Humans have feelings. Small humans have *strong, huge* feelings. And don't have all the perspective you carry with you today. Be kind to that younger part of you doing the best you could.

PROJECT 4
RESPOND

> *How do you think Jesus would have responded to the little child in your memory you wrote down in Project 3?*

"Jesus said, 'Let the little children come to me, and do not hinder them, for the kingdom of heaven belongs to such as these'" (Matthew 19:14 NIV).

CONCLUSION

Untangling our complex feelings all starts with noticing: what we're sensing in our feelings, whether we'll admit that those feelings are true for us, and when the emotions we're experiencing first showed themselves in our lives.

We're not trying to control them. Not judging them. Just noticing. Easy, right? Or not easy at all. If you're finding this hard or scary, I want to extend so much compassion to you. I want to take your hand and say, *I know. This is hard for people like us.* We want to "handle" the emotions. But this pure, simple noticing is such a worthwhile start.

As we move together through the process of connection with our emotions, I encourage you to invite God in.

If you are scared of feeling these feelings, ask Him for strength to face them.

If you are confused about what you are feeling, ask Him for insight and clarity.

If you are overwhelmed with feelings, ask Him to issue peace that surpasses understanding.

If you are numb and don't feel anything, ask Him to wake up your heart.

He loves you. He made you. He made these emotions so that you would draw near to Him. This is how we do that. Talk to Him about it all.

> "Would not God discover this? For he knows the secrets of the heart" (Psalm 44:21).

SEE ::

Watch video session two: **NOTICE**
Take notes if you like.

ASK ::

Use session two: **NOTICE**
Conversation Cards for group discussion.

SESSION 3

NAME

Work through pages 56–74 on your own before your next group
meeting and before you watch the next video teaching.

Humans have a deep-seated need to name stuff. We name our children. We name our vehicles. We nickname our friends. We ascribe meaning to just about everything as a way to set it apart, as a way to honor it, to keep it organized.

But why is it so hard to name our feelings?

Many of us weren't taught how to identify our feelings. Or we were discouraged from giving voice to them. Many of us even wonder if when we feel sad or angry that it might be a sin! Some of us even learned that if we feel happy, we are probably wrong. Or that if we feel bad, we should feel bad about feeling bad, because our lives really aren't that bad.

We can be so judgmental about our feelings.

But emotional maturity is the ability to *feel what we feel*, without judgment or without being controlled by our emotions. Emotional wholeness begins by *noticing*, and then *naming* what we feel so we can determine what to do in response.

What Is a Feeling, anyway?

Too many of us don't have a vocabulary to describe our feelings. Or we've misunderstood what constitutes an emotion.

Clinical anxiety and depression are not examples of feelings.

Feelings are *grief* and *worry* and *anguish*. And *hope* and *contentment* and *joy*. Because we've never learned to name and share and feel these feelings, we end up with *pathologies*. Yes, sometimes it's brokenness in our body, and there's nothing to do except treat it as a medical condition.

But even with a diagnosis, we have to learn to feel the spectrum of all the feelings. Any doctor or counselor will tell you—it's not enough to treat the problem. You must learn to name the pain, share the pain, and heal from the pain.

Last week we started with noticing what's going on with our bodies and specifying *okay* or *not okay.* This is the next step: gaining more clarity on what we're actually feeling. Naming them.

Even if you've treated your emotions like "those that must not be named" for fear that naming them makes them more real, *naming* is a gift you've been given by God who names everything and everyone as an example of its value.

STUDY ::

Read John 4:1–29

> *What did Jesus want from the woman?*

> *What did the woman get from Jesus?*

> *How did she respond to what Jesus told her?*

> *Why was "naming" where she was coming from, in truth, important to the message she was giving at the end of this story?*

During His ministry on earth, Jesus was constantly asking people questions. He wanted to illicit responses—for people to consider and name what was going on in their heart. Let's look at one instance in which He helped a woman name her struggle, so He could set her free from it and offer her new life.

When Jesus told the woman "go call your husband" and come back to the well, He wasn't trying to embarrass or shame her. He was inviting her to name her reality. When she held back, He helped her name it, because He already knew. He knew why she had a need for the Living Water He offered, and the pain she must have faced because of the way she was living, and the way the people around her must have been treating her.

He met her exactly where she was. Not only did He name what was going on with her; He offered her the Living Water, or a relationship with Himself, and an invitation to worship the Father *in Spirit and in truth*.

He established a baseline of *truth*, too—and this is where her healing began.

Are you coming into this study with any questions or negative experiences as it relates to naming your emotions? If so, describe them.

Read Genesis 6:5–7

What troubled God here? For more context read Genesis 6:11–13.

> *If God is omniscient and knew mankind would disappoint Him, what does this passage teach you about God's choice to create anyway?*

> *Why would God open Himself up to feelings of regret and grief? Why do you imagine He considered it worth it?*

Read Romans 8:26–27

In this passage, describe man's weakness and the role the Spirit plays for man.

> How does this encourage you when you think about the times in your life when it's been hard to put words to your circumstance?

> What does it mean to you, in the process of naming your emotions, that the Holy Spirit helps you?

When you are experiencing a feeling that is throwing you for a loop, ask these questions of God:

What do You want me to know? What do You want me to do?

USING OUR WORDS

Now we can practice naming our own emotions. There are four main emotions we will focus on together: joy, anger, sadness, and fear. For each one, let's discover the other words we can use to move from just saying "sad" to "melancholy" or "disappointed."

Joy can be a complicated emotion. I recently saw a scan of a brain all lit up with enjoyment. The next image showed the brain all lit up with fear. While the emotions were identified with completely different colors, it was clear they were showing up in similar regions. You can't turn off the parts of your brain that feel sadness and anger without also shutting down your ability to feel joy.

Sometimes we feel guilty if we aren't joyful, as if it is the absolute required state for people of faith. We're supposed to have the joy, joy, joy, joy down in

our hearts, right? Then sometimes we feel guilty when we feel happy, because frankly, the enemy loves to steal, kill, and destroy joy.

But Christ knew and expressed joy and He came to share it with us. He delighted over children, over meals with friends, over people coming to faith, over people being healed, over wine at a wedding. Joy is a gift from Him, reflecting His image when we feel joy.

God never says, "Don't ever get angry." God knows we will get angry; He knows because He got angry too and we are made in His image. God's call is that we be *slow* to anger because He knows we are so easily offended. And in doing this we live like God, "The Lord, a God merciful and gracious, slow to anger, and abounding in steadfast love and faithfulness" (Exodus 34:6). He also calls us to not sin in our anger, and that is the hardest part.

A lot of times, anger is a reaction to something alarming. God built a system in your body to react to any danger or threat you might face. You've probably heard of "fight or flight" instincts, right? That "fight" response might pop out completely unbidden. And for completely biological, healthy reasons.

It is helpful to understand and accept that you *will* get angry. But noticing and naming your anger is essential to a godly response.

When was the last time you cried? When was the last time you pushed away sadness? What triggers your sadness most often? Do you feel bad about being sad? This is where I wish I could sit across from you and say, "*I'm sorry.*" There is some comfort for us that sadness is actually in the Bible A LOT, where it's often called *lament*. The prophets lament, God's people lament, and even Jesus laments in the garden of Gethsemane. And psalm after psalm in the middle of your Bible is full of lament.

"When Jesus saw her weeping, and the Jews who had come along with her also weeping, he was deeply moved in spirit and troubled. 'Where have you laid him?' he asked. 'Come and see, Lord,' they replied. Jesus wept" (John 11:33–35 NIV).

There's not a right way to be sad. You're just sad. There's not a right way to go through trauma. Sometimes weeping is all we can do, much like Jesus after His friend died.

Fear, by design, is meant to keep us safe. Sometimes it tells you there is imminent danger and sometimes it scares you about an unknown future, robbing you of sleep. We so quickly demonize it. I think of how long I misunderstood all the command language throughout the Bible to not fear. I've heard a hundred sermons on it telling us how much God does not want us to fear.

But those words are from a loving, safe Father speaking to His child who is freaking out, crying and afraid.

"But immediately Jesus spoke to them, saying, 'Take heart; it is I. Do not be afraid'" (Matthew 14:27).

Fear is your constant reminder you need closeness and proximity to God, and He is with you. He is with you in the valleys.

Like every emotion, fear can become a negative stronghold, but it is more likely to do so if you do not notice it, name it, and share it with others.

> *When was the last time you remember feeling afraid? How can you imagine God viewing you in that moment?*

> *Do you have a complicated relationship with joy? When have you been conflicted in feeling it?*

> *God shares in our joy, our sadness, our anger, our fear. In what ways does this truth make you feel comforted or even conflicted?*

> *How could you be more descriptive about what you're feeling? What three words would you choose to describe your emotional state?*

WHO ARE YOU, LORD? **&** WHAT DO YOU WANT FROM ME?

Read John 15:11. In light of what you read, answer the questions above.

DIGGING DEEPER
(OPTIONAL PROJECT FOR THOSE OF YOU WANTING TO GO DEEPER)

Read John 15:9–14

> *Write every verb used to describe what Jesus does in this passage. Beside each one, write what the passage says should be our response.*

VERB	RESPONSE

Scripture uses the word "full" or "complete" when it comes to the joy Jesus offers. Based on verses 9, 10, and 12, what specific actions make our joy complete?

PROJECT 1

REFLECT

> *Think of a time this week when you felt: sad, angry, joyful, or afraid.*

> *Where did you feel that in your body?*

Remember you can be feeling more than one emotion at the same time. Just choose the most obvious one.

You can go back and look at last week's Project 2 if you need help (pg 47).

PROJECT 2
NAME HONESTLY

▷ *Name what you were feeling in a more specific way.*

▷ *The varying shades reflect the intensity of the emotion. Circle the most descriptive word to the feeling you identified in Project 1.*

JOY SATISFIED **AMUSEMENT PEACE COMFORT REJOICING DELIGHT EXCITEMENT**

ANGER IRRITATED **FRUSTRATED BITTER HATRED OUTRAGE RAGE**

SADNESS DISAPPOINTED **MELANCHOLY LONELY HELPLESS HOPELESS GRIEF ANGUISH**

FEAR UNREST **DOUBT NERVOUS WORRY DREAD PANIC TERROR**

PROJECT 3
BRANCH OUT

> Take the more descriptive name for the feeling you identified in Project 2 and write it in the circle below.

> Think of other times you have felt this emotion and write some of the things that make you feel that way around the circle.

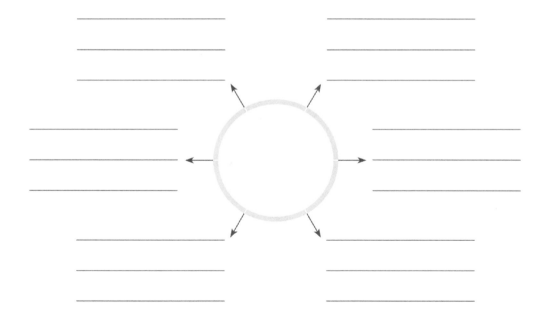

PROJECT 4

"I FEEL"

We will dive into a deeper way to share our emotions with others for the purpose of connection later in the study. This week I want you to say out loud what you feel to somebody safe as you're going through your week. It will feel awkward and random—just prepare your people. Tell them you're doing a Bible study and have to do this exercise.

> *Say, "I feel _____ " out loud throughout the week.*

> *Write down here what you were able to name, when, and to whom.*

It's going to take some practice to make naming our feelings a stronger habit than evading them. So, this week, just focus on pausing periodically noticing how you feel and naming the feeling. Maybe out loud. Maybe not.

As you start to name your feelings, remember how God the Son, the Father, and the Holy Spirit name what is true and will help you do the same.

CONCLUSION

We need words to make better sense of things. With more words, things make far more sense.

But it's going to take some practice to make naming our feelings a stronger habit than evading them. So this week, just focus on pausing periodically and telling yourself how you feel.

Right now. How do you feel? Look at your response on the previous page and pick the most specific word you can.

If you don't like talking to yourself out loud, then you're welcome to just think the thought. But I want you to actually think or say a complete sentence about how you feel at different points.

Eventually we'll get to sharing these feelings, but again, I'd encourage you to start awkwardly sharing the words you choose all along. If you're doing the study in a small group of people, hey–you've got some awkward sharing buddies built in. If you're not, start to gather those people.

You might say to yourself, "I feel hopeful in this relationship." Or maybe, "I feel encouraged with my progress so far." Or "I feel excited about this assignment." Or "I'm not angry . . . I feel just curious."

Maybe you feel somber. Or joyful. Or grateful for something simple in your day. Maybe you feel irritated. Or exasperated. Or feisty. Or ecstatic. Or calm.

Fight to go beyond telling yourself something benign, such as, "I feel fine." "I feel okay." "I'm good." There is a whole world of emotion going on inside you. As you start to name it, remember how God the Son, the Father, and the Holy Spirit name and encourage you to name what's true about you. Borrow His strength if you need to. And let that naming keep you returning to Him.

SEE ::

Watch video session three: **NAME**
Take notes if you like.

ASK ::

Use session three: **NAME**
Conversation Cards for group discussion.

SESSION 4

FEEL

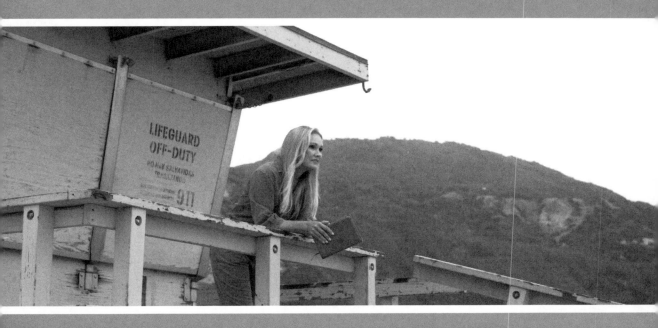

Work through pages 80–96 on your own before your next group
meeting and before you watch the next video teaching.

Learning to feel has played out in hysterical ways in our home. "I feel ____ " has come out of my mouth way too much as I have been working on this project for that last year. Zac has learned to laugh and listen and nod. Recently, he said, "I try not to let everything you are 'feeling' affect me because I know soon you will be feeling a different feeling."

It's true naming and feeling our feelings might feel awkward at first. We might be bumping into each other and saying things in a way that feels cumbersome. But it is worth pushing through the awkward and feeling our feelings! It has been a practice for me to notice and name and especially to give space to actually feel what it is I am feeling.

But it has set me free as I have leaned into the way God has built our emotions rather than fear them. God has drawn me closer to Himself and closer to the people I love because I have gotten more comfortable with tears and frustration. Laughter and peace has come more easily, too!

FEELING OUR FEELINGS

The truth is, so many times in life, feeling our feelings is unavoidable. They slap us with their presence. Maybe you've felt your stomach knotting up. Your cheeks getting hot. There's no escape from the emotions. They show up without an invitation and they demand attention.

But then again, sometimes we just say to ourselves, *Now is not the time.* We have to soldier on. How often do we have a choice of whether or not we feel our feelings? As we know, with the three C's as our go-to (cope, conceal, control), we can tuck them away, compartmentalizing them into a little spot in the back of our minds to deal with later—or maybe never if we have our way. I want to tell you, if the prospect of feeling your feelings is too much to deal with right now—if you are working through trauma, or simply haven't got an ounce of energy left to spare—I hear you. You can let them wash past you for now. Just build yourself up now in your knowledge of your feelings and the way God sees them, sees you, and when you're ready, come back to this step. When you can sit in your feelings—and especially sit with Jesus in your feelings—you'll find that there is a strengthening that happens. Whether you do it on your own, letting the tears come, or with the help of a professional counselor (which I cannot recommend enough), there's grace to feel what you need to feel. And when you need to feel it. No judgment here.

For the past three weeks, we've been talking about the moves we make to untangle the knots in our feelings. We have *noticed* our feelings. We have *named* our feelings. And now at last we *feel* them. You could say that this step is the most important of all!

It may strike you as funny that we have to include this step—ready, set, *feel*!—but if you're a recovering "fixer" like me, then you'll quickly realize the benefits of being forced to "feel" instead. You may have to practice it. It may be awkward and intimidating. But I'm here for you in it.

And so is God. I hope you feel His grace for you. His nearness. He is not distant and judgmental of what you feel. He wants to comfort you. Run to Him in this process.

Let's look to the Bible to see the way that the Father, the Holy Spirit, Jesus are really calling us out of avoidance, and into places of joy and connection. Even sadness and connection. Fear and connection. Anger and connection. Of all the difficult emotions we've discussed, all of them can potentially lead to connection. Still, they have to be felt.

But first, it's worth repeating that God Himself expresses emotions. He gets angry and disappointed and even afraid.

God, afraid? Yes. See for yourself.

STUDY ::

Read Luke 22:39–46

I want to take you to the night before Jesus, God the Son, would be crucified. That's one time when God the Son shows the intensity with which He feels.

> *What emotions do you imagine Jesus feeling from these words?*

> *Where did Jesus go with His emotion?*

> *What did He want from His friends in His grief?*

Jesus knew what was coming: death on the cross. And He felt anguish, to the point of sweating blood. *Anguish* is a secondary emotion for fear. I believe we get this intimate glimpse into the relationship of a Father and Son so we are not left with this guilt trip when we're afraid. Instead, we have the picture of a Son running to the Father with His extreme emotion. Even reaching out to His imperfect human friends. Jesus isn't just our means of salvation; He was also sent to be an example we follow.

EMOTIONS ARE NOT SIN

Maybe you feel guilty because you feel afraid or sad so often. Maybe you feel guilty because you feel happy so often and your friends don't. Apparently, it's not enough that we are tangled up in our feelings. We add another conflict to the mix: the voice of judgment telling us we "shouldn't feel that way."

The Bible tells us this about Jesus:

> "Since then we have a great high priest who has passed through the heavens, Jesus, the Son of God, let us hold fast our confession. For we do not have a high priest who is unable to sympathize with our weaknesses, but one who in every respect has been tempted as we are, yet without sin. Let us then with confidence draw near to the throne of grace, that we may receive mercy and find grace to help in time of need" (Hebrews 4:14–16).

You can feel all your feelings and not sin. And you can feel all your feelings and sin. But *feeling a feeling* in and of itself is not a sin.

Feeling your feelings is an invitation to "with confidence draw near to throne of grace, that we may receive mercy and find grace to help in time of need" (Hebrews 4:16). For many of us that idea will take some getting used to. So let's look together throughout Scripture to see the way God feels.

GOD THE FATHER FEELS

READ	WHAT DOES GOD FEEL TOWARD YOU?
Matthew 10:29–31	
Romans 8:38–39	
Zephaniah 3:17	
1 John 3:1	

Despite what you may have been taught, your emotions are not symptoms of sin or a lack of faith. Your emotions are meant to grow your faith, meant to lead you into deeper relationship with the One who made you and who created the very emotions you feel to be felt.

> *How does reflecting on the way God feels about you help you feel comfortable taking your feelings to Him?*

▷ *Go back and read the words you filled in on the chart. What does it mean that God feels this way,* in every emotion you have, *without judgment?*

EXAMINE OUR RESISTANCE

Even as I come to this moment asking you to fully embrace and engage some emotions, you may not be comfortable with feeling. I'm so tender that this might be difficult for you. Let's start by describing the resistance you might feel.

▶ **I don't know what you're asking of me. I'm confused. How do I know I'm feeling and doing it right?**

If this is you, you are a person after my own heart. I'm always wondering whether I'm "doing it right." But this isn't something you can really mess up. What I would say, is that feeling comes naturally. You could do it from the moment you were born. If we commit to *not stopping* the feelings, they will just come.

Here are some ways to *not stop* the feelings:

Be bored. Let your mind rest. Don't distract yourself with entertainment or various problem-solving endeavors. Just block off some time and sit around for a while. Give yourself some quiet and see what comes up.

Give yourself permission. Permission to feel even the difficult things. You don't have to "behave" or "be nice" or "count your blessings" to fend off the feelings. Refrain from judging. Refrain from condemning. Accept the feeling, exactly as it is.

Look back. As you feel, look back. When was the last time you felt these things? How did you get through?

Persist. Don't look for a way out. Go through. Just accept the feelings and let them run their course. Psychologists tell us that the more we do this, the faster we recover. Stick with it, and you will feel the wave pass.

▶ *I don't want to feel the negative emotion.*

Again, I get you. You may need to wait till later. You may need to get some help and support from a licensed counselor and/or friends and loved ones. For now, remember there is something on the other side of this difficult emotion.

▶ *I don't see the purpose of this. I have so much to deal with.*

I've spent seasons of my life feeling "comfortably numb" so I could do what I needed to do. Until it became "uncomfortably numb." And then became a hollow, unfulfilling life. You need to *feel* to live life fully. If you are exasperated with this process, I sympathize. I have been known to ask my counselor the equivalent of "Are we there yet?" what feels like every twenty seconds during this ride toward emotional wholeness. It will take time.

Remember, your emotions are coming out somehow. If we stuff them, we don't get to choose how. But if we feel them, we can begin to learn how to manage and regulate them.

WHO ARE YOU, LORD? & WHAT DO YOU WANT FROM ME?

Read Hebrews 4:14–16. In light of what you read, answer the questions above.

DIGGING DEEPER

(OPTIONAL PROJECT FOR THOSE OF YOU WANTING TO GO DEEPER)

> *In Luke 22:44, look at the word "anguish" or "agony" and its Greek equivalent. Do a word study of how that word appears throughout the Bible.*

PROJECT 1
IDENTIFY

▷ *Are you more likely to **conceal**, **cope**, or **control** when faced with feeling an unwanted feeling? Circle one.*

▷ *What does that look like for you?*

▷ *What are you missing because you are choosing to conceal, cope, or control?*

PROJECT 2
CONTRAST

▷ *Compare one time you felt an emotion you needed to feel vs.
a time you suppressed a feeling you needed to feel.*

▷ *How did each of those events affect you? What were the
aftereffects?*

	FELT	SUPPRESSED
EMOTION		
AFTEREFFECTS		

> *How did they affect other people?*

> *Did the suppressed feeling come out in any way? How does the thought of that feeling strike you today?*

> *Did the expressed / felt emotion feel easier the next time you felt it? How did you express it?*

PROJECT 3

ADMIT

> *Think of a time you felt a big feeling.*

> *Describe in detail what that moment felt like. What was happening in your body? In your mind? Around you?*

> *Was there part of you that judged the feeling? If so, why?*

All of us tend to judge our feelings. And the enemy uses this to further confuse our emotional lives. But we know that "God is not a God of confusion but of peace" (1 Corinthians 14:33). To get to the place where you can simply feel, without judging the feeling, you may have to force yourself to stop and reach out to Him. You may have to borrow some of His compassion demonstrated all throughout the Bible and apply it to yourself. He will always bring you through.

PROJECT 4
IMAGINE

▷ *Go back to the spot you originally noticed your feelings in Session 2.*

▷ *Pick a playlist based on your mood and the emotion you want to feel and push play.*

▷ *Invite Jesus into the feeling you are feeling today and ask Him what He thinks of it.*

Remember, we are going to get to what we do with the feeling in the next lesson. For now, get in the practice of not judging your feelings and just feel them.

CONCLUSION

I didn't realize it was possible to have so many parts of myself until I went to counseling. Part of me can feel afraid and part of me can be excited and part of me sad at the exact same time about the exact same event. Somehow, I didn't know that. I just felt confused.

Understanding that part of you can experience one thing and part of you can experience a wholly different thing at the same time is part of what it means to be human. It's part of the capacity God gave us, made in His image, to carry many things all at once.

You feel. You are not your feelings.

I've learned nothing is better at helping me make sense of confusion or the knots in my soul than asking these two questions, inviting God in hour by hour sometimes.

God, with this feeling I'm feeling, what do You want me to know?

God, what do You want me to do?

He is waiting to lead you beside still waters, to shepherd your soul! He's inviting you to come close and feel your emotions in the safety of relationship with Him.

"Cast your cares on the LORD and he will sustain you;
he will never let the righteous be shaken" (Psalm 55:22 NIV).

SEE ::

Watch video session four: **FEEL**

Take notes if you like.

ASK ::

Use session four: **FEEL**
Conversation Cards for group discussion.

SESSION 5

SHARE

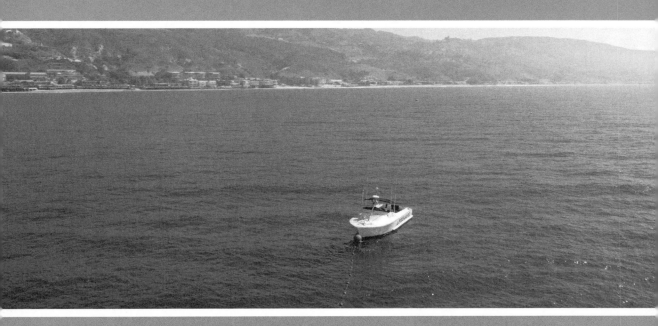

Work through pages 102–118 on your own before your next
group meeting and before you watch the next video teaching.

I watched my husband, Zac, live these words as I wrote them. After years working on a company, it suddenly all came crashing in. It was devastating on several levels. So, as I was writing about emotions, he was feeling all of them. He cried when he needed to cry; he shared everything with his closest people; he wasn't afraid to face all his sadness and to feel it.

For months he was quiet, and some nights told me all the unfair parts that were making him just flat furious and other nights it was worry about our futures and sometimes it was sadness that in some way he had let us down.

And an amazing thing happened over the last several months, somewhere along the way, things began to shift. Nothing had changed in our circumstances, but he got lighter and more hopeful and peaceful again, there were even some nights he laughed.

The fact was, Zac never felt alone, even when his depression was at its worst. This was because people who had been where he was came alongside him and refused to let him drown. Their sheer presence told him day by day that, despite how crappy he felt, despite how unknowable he seemed to himself, things would get better over time. He would make it to the other side.

"Mourn with those who mourn" was part of the way God intended for us to help rescue each other emotionally. We were built to feel. And we were built to feel together.

TIME TO SHARE

After you go through the paces of noticing, naming, and feeling a feeling regarding a situation you're facing, it's time to open your mouth and *share*. Get yourself in the presence of someone you know and trust (and preferably like) and practice saying a few simple words: "I feel _____" and insert an emotion there.

You practiced this in Session 3; now we will take it a step further. First, start off with saying it to God. If you can, get in a place where you can speak out loud to Him. That can be revolutionary—you're not just *thinking* about how you're feeling but *saying* it. Then that rope that your feelings make between you and God starts to untangle. You start to get honest. You start to know His compassion for you.

When it comes to doing this with other people, like so many other things in this process, awkwardness is par for the course. You won't get it right every time, especially at first, but getting it right isn't even the point. For now, it's enough to get used to hearing yourself say, "I feel ..."

You might be thinking, *How is this helpful? It doesn't change anything. My problems are still my problems, and I have to deal with them regardless of how I or anyone else feels about them.*

It's one thing to have to feel all your feelings, and it's a whole other thing to have to share your true feelings with others. I get it. It sucks. I feel that way every time I'm about to do it. But I never feel that way *after* I do it. I always am grateful I shared.

You *can* live in meaningful connection with others—with God, with yourself, and with the people God puts in your path.

NOT A BURDEN

Maybe you're thinking about the process of sharing what you're going through, and you just don't want to think about the effect it might have on other people. Many of us were taught we shouldn't burden other people with our problems.

But how can we ever get really, truly close to each other if we don't share vulnerably?

Whenever you hide from vulnerability to avoid being misunderstood, wronged, rejected, or hurt, you also keep yourself from the good things of compassion, love, and realizing you're not the only one. Sharing brings us connection and healing.

God does more than encourage us to share our difficulties with each other; He commands us. Galatians 6:2 says, "Bear one another's burdens, and so fulfill the law of Christ." Fulfill the law of Christ by sharing burdens? That sounds intense. It sounds important. It sounds necessary.

When Jesus says, "My yoke is easy, and my burden is light" (Matthew 11:30), He's not saying life is going to be easy. In other passages He says there is trouble in this world, and He calls us to pick up our crosses. The burden is light because He is with us, and His presence and comfort and friendship make life easier and sweeter. He makes suffering easier because He never leaves us and will carry it along with us.

SHARE SAFELY

Another objection to sharing your feelings you might have is this: *If I share, I might be rejected. I couldn't handle that.* Well, it's possible. It's a risk we take. Would you believe me if I told you it's worth it, though? That we can't move forward without it?

We cannot control the outcome of this kind of vulnerability, but we can better our chances by choosing someone who has demonstrated in other ways they would be safe with your feelings.

What might this person demonstrate?

Availability—Look for people who say yes and show up, even when things are nuts or their house isn't clean or when everything isn't perfect.

Humility—They say hard things and they receive hard things, and they're honest, but they're not about to think they can fix you. They're thoughtful, and not likely to fly off the handle. Or they're willing to respond positively to a request for a purely listening ear, and no fixing.

Transparency—Look for someone who refuses to hide, someone who will say what's really going on. Watch for the one who is capable of answering your "I feel" with a real-life "I feel" in return, and won't pretend like everything's fine and should be hunky-dory.

Obviously, healthy friendships are going to have conflict and bumps and misunderstandings, but in my experience, these three qualities in a relationship are the markers for a safe place for my feelings.

I should mention here that the apostle Paul wasn't afraid to caution us against aligning with unhealthy people we should avoid. Paul talks about people who live as if "their god is their belly, and they glory in their shame" (Philippians 3:19).

In other words, people who are comfortable in their sin, people who mistakenly believe that they don't need to change, those should not be the ones who make up your inner circle.

If you are running with people like this, you will get complacent fast. **Our flesh loves to not be bothered about its sin.** Run—don't walk—away from toxic people who will lead you into sin and away from God.

Instead, choose friends who will fight for you, friends who will meet your honesty with compassion, and friends who are as committed as you are to emotional health.

Ask God right now to bring these people to you in unexpected ways. Believe that He can and wants to bless you with people to receive your feelings, to feel them with you, to be there as you work them out. Ask that He help you become a safe person for others to share with.

Because God is all about sharing and being shared with. He designed this in our human makeup. And He gave us examples of the value of sharing in the Bible. Jesus experienced one of the most vulnerable sharing moments we see in Scripture.

STUDY ::

Read John 11:1–4 and 17–44

> *How does Jesus move toward Martha in her anger?*

> *How does Jesus move toward Mary in her sadness?*

From reading these verses, knowing that Jesus knew He would raise Lazarus from the dead, why can you imagine He cried?

> *How does the fact that Jesus shared and wept with those who were weeping, despite being all powerful, change the way you perceive "sharing feelings" with those around you?*

Imagine Jesus' feelings after the death of his good friend Lazarus. And imagine Mary and Martha's. He does not run from their grief and their vocalization of it.

How many times have we been angry at God but scared to say so? Jesus did not shame Martha. He comforted her and reminded her of eternal hope: "I am the resurrection and the life. The one who believes in me will live, even though they die; and whoever lives by believing in me will never die" (John 11:25–26 NIV).

And then Mary, who is totally broken and crying it out in front of Him, He joins her in her tears. He could totally "fix it," to bring Lazarus back, and tell them to dry their eyes and change their feelings. But instead, Jesus meets them there, where they are. He comforts them.

> "Love must be sincere. Hate what is evil; cling to what is good. Be devoted to one another in love. Honor one another above yourselves. Never be lacking in zeal, but keep your spiritual fervor, serving the Lord. Be joyful in hope, patient in affliction, faithful in prayer. Share with the Lord's people who are in need. Practice hospitality. Bless those who persecute you; bless and do not curse. Rejoice with those who rejoice; mourn with those who mourn. Live in harmony with one another" (Romans 12:9–16 NIV).

List what the apostle Paul is calling us to do in these verses.

▷ *Look at verse 1 of Romans 12. What is the motivation for this way of life?*

> *Look at verse 2 of Romans 12. What is the result of a life like this?*

SHARING LEADS TO HEALING

God built our brains for connection. Studies[1] show that verbalizing our feelings to one another helps us deactivate the brain's "alarm system," the part of our brain that sends us into fight-or-flight. Sharing helps heal our emotional pain and can reduce stress, strengthen immune systems, and make us *actually* see improvement physically and emotionally. So not only did God design us to feel, but He also designed us to feel *better* after we connect with others and with Him.

With all of this in mind, I have a challenge for you: The next time you're in a conversation with someone, instead of responding to a story or update with a "That's great!" or an "I think …" force your lips to form the words, "I feel." Take it from a fixing situation or a surface situation to a sharing situation—a healing situation, no matter how trivial it may seem.

That's it! Nothing more.

1 Diane E Dreher, "Why Talking About Our Problems Makes Us Feel Better," *Psychology Today*, June 11, 2019, https://www.psychologytoday.com/intl/blog/your-personal-renaissance/201906/why-talking -about-our-problems-makes-us-feel-better.

You've just opened a new line of communication, where you're not *thinking* each other through solutions but connecting on a human level. All with two little words. *I feel . . .*

Step one: Start sharing by saying, "I feel . . ."

Step two: Ask whomever you share with for an "I feel . . ." statement in response.

This is a way to retrain yourself from defaulting to fixing and problem-solving, to strengthening and untangling the rope of feelings that binds you to others.

> *In what situation can you try pulling out an "I feel" today?*

> *Who in your daily encounters can you ask for an "I feel" in return?*

WHO ARE YOU, LORD? WHAT DO YOU WANT FROM ME?

Read Matthew 11:28–30. In light of what you read, answer the questions above.

DIGGING DEEPER
(OPTIONAL PROJECT FOR THOSE OF YOU WANTING TO GO DEEPER)

> *Look up the Greek words for "bear" and "burden" found in Galatians 6:2. Write down their definition. How does this expand your view of how we are to share vulnerably?*

PROJECT 1
JOURNAL

> *Write a prayer to God sharing with Him your biggest feeling this week. Include times you know He felt these emotions from Scripture. (Don't be afraid to look online for passages in Scripture!)*

PROJECT 2

PLAN

Many times, there are very valid feelings we don't want to share with the people we love. Let's take some of these reasons and build a plan for how we could share with the people we love and have the best possible outcome.

▷ *I am afraid they will* _____ . *Share something like . . .*

I am afraid they will try to fix me.	**Share something like . . .** *I want to tell you something I have been feeling and I need you to not fix it. I just want you to listen.*
I am afraid they will judge me.	**Share something like . . .** *I am going to share something with you, and I would love to know how it makes you feel when I share it with you.*
I am afraid they will tell me why I shouldn't feel that way.	**Share something like . . .** *I'm trying to learn to stop judging my feelings. Can you just help me out as I learn to feel them honestly first, and only do something about them after I can do that?*
I am afraid they will misunderstand what I am saying.	**Share something like . . .** *I'm worried about being understood, so maybe you can just listen and nod and let me do this awkwardly, and if it's hard to understand let me know.*

PROJECT 3
REFLECT

> *Connect with a trusted person, or a few, and commit to filling out this Mad Lib together and sharing it with each other. Then discuss how it makes you feel to hear this from each other.*

The biggest emotion I felt this week was _____.

The reason I felt _____ was _____.

That feeling makes me feel _____, so

I wanted to _____ the feeling.

I remember first feeling _____ when I was _____ years old. I was this old when _____ happened. When I think about myself back then, it makes me feel

_____.

I wish I could tell myself back then _____

_____.

PROJECT 4
CELEBRATE

> *Have a celebration dinner with two to three people you feel close to and tell them about your emotional journey thus far. Share especially these parts of your story:*

- ▶ Share why it has been difficult in the past to feel your feelings and share them with the people close to you.

- ▶ Share some of the feelings you have noticed in the past few weeks.

- ▶ Share how your family of origin shaped your view of emotions.

- ▶ Share what you hope for these relationships in the future.

- ▶ Share the hope you have for a deeper emotional connection for those in your life in the future.

- ▶ Ask for sharing in return.

CONCLUSION

Here's the thing: resilience grows as we notice, name, feel, and share our feelings and in doing so learn that we are seen, soothed, and safe.

The hard stuff is actually building us into who we are, as the apostle Paul knew so well. He said to the church in Rome: "We also glory in our sufferings, because we know that suffering produces perseverance; perseverance, character; and character, hope. And hope does not put us to shame, because God's love has been poured out into our hearts through the Holy Spirit, who has been given to us" (Romans 5:3–5 NIV).

Sharing doesn't disappoint. Because we have a rope of emotions connecting us, pulling us into each other and closer to God. The gift of feeling and moving through the messy middle of life together? It's agonizing beauty. Feelings don't heal when we ignore them—they heal when we are wrapped up by the people we love in the middle of them.

Resilience, maturity, connection, character, and hope growing right before our eyes, in whatever messy place we are… together.

"Bear one another's burdens, and so fulfill the law of Christ" (Galatians 6:2).

SEE ::

Watch video session five: **SHARE**
Take notes if you like.

ASK ::

Use session five: **SHARE**
Conversation Cards for group discussion.

SESSION 6

CHOOSE

Work through pages 124–146 on your own before your next group meeting and before you watch the next video teaching.

How often have we all tried compartmentalizing our lives? We convince ourselves that…

We can be a great worker.

We can be a great parent.

We can be a great spouse.

We can be a great college student.

We can be a great Christian.

And yet still be a disaster emotionally.

Nope. Emotions affect everything.

We all want to be emotionally healthy.

So now what?

We notice it and name it and feel it and share it and then what?

What if it still feels like it still may take us under?

We've come to the point in this process—and we'll come to it probably dozens of times every day—where, once we notice what we feel, name what we feel, actually feel it and share it, we have to decide what to *do* with it.

And the thing is, even *not* doing something with it is technically doing something with it. Maybe up to this point you've stuffed feelings, ignored them, put the tangled-up mess of them in a box on the shelf of your heart. But they're still there.

Or maybe you've let your emotions run wild and allowed them to control your day, your year, your life.

Either way, you've decided, whether intentionally or not. But you have another option: You can feel it, share it with the people you love, and let it draw you closer to the God who wants to carry your burdens. As 1 Peter 5:7 says, you can "cast all your anxiety on him because he cares for you (NIV)."

Choosing to engage this process leads to wholeheartedness. It leads to connection. It leads to the kind of life God built for us. And wants for us.

So, are you ready to choose what to do with your feelings?

Let's start off with a simple choice. One that's critical if you want to stay on the road to health.

First, we choose to do this with God. To stick with Him, because He is our source of healing. Let's look at how this choice plays out in the Bible— how we choose Him, and He chooses us.

STUDY ::

Read Matthew 8:23–27

> *What were the disciples feeling?*

> *Where did they go with their feelings?*

> *What did Jesus say? What did Jesus do?*

> *What was the result for the men?*

The thing I love about this story is the way the disciples grow after it. Later in the New Testament, after Jesus returns to heaven and sends them on a mission to share the gospel with the whole world, we are looking at a whole different set of men. They are bold. They are brave. They are literally facing death to bring the good news to as many as they can.

Acts 4:13 says,

> "When they saw the courage of Peter and John and realized that they were unschooled, ordinary men, they were astonished and they took note that these men had been with Jesus" (NIV).

They stuck with Jesus. They learned from Jesus. And they went from people who were overcome by emotion at a stormy sea to those who displayed supernatural courage.

That comes from *choosing* Jesus over and over. Choosing to go through this process with Him, for a lifetime.

Jesus untangles our emotions through seasons of tears, cussing, and running back to Him again and again because He cares for us. He cares for you. He wants all of you. He wants you to believe it all.

Honestly, I wish my relationship with God was not built through tears and cussing. But then again, I wouldn't trade it. Because I don't see another way. These feelings that all my life I've been afraid to feel—they are the tether God's got wrapped around my waist pulling me in closer and closer and closer to Him. If I let Him, and don't fight it by concealing, coping, and controlling, it's scary, but I find my home and comfort in Him. *First, we choose God.*

Read Ephesians 4:25–32

Let's go back to a verse we've touched on before. This one is talking about the choices we make in response to our emotions, and how those choices connect us to the Holy Spirit.

> *In verse 26, is anger sin?*

> *What is the emotion the Holy Spirit is feeling in verse 30? Why is He feeling it?*

> *From the whole passage, what are the things God wants us to get rid of?*

> *What are the things He wants us to put on?*

In this passage, choosing a connection with God is closely tied with what we do with an emotion. In this case, it's anger. But it could be any of them. We choose to be honest.

First, we choose God. Next, we choose the raw unvarnished truth.

We must be honest about where we are and our desperate need for God.

Sometimes the "truth that will set you free" is saying to God and to others what is true about the state of your heart so that together you can believe God for those places in you, too.

But sometimes the truth about what you are struggling with is not sin. Many times, you emotionally hit a wall because life just sucks, and our bodies are broken, and they just don't function how we wish they could.

Because it is all so broken. But the Bible issues hope for the brokenness.

"Those who sow in tears shall reap with shouts of joy!"
(Psalm 126:5).

God isn't afraid of the brokenness, and we shouldn't be either. He has a plan to set us free.

Read Revelation 21:1–5

> *From these verses, what is God's ultimate goal for our sadness?*

> *What is the promise for our future with Him?*

> *Looking at our emotions considering this, why can we choose God? Choose honesty? And finally, choose to let God make us new, as He makes the world new?*

THE PURPOSE FOR OUR FEELINGS

We have a God who issues descriptions of heaven as a place where He will personally, intimately wipe every tear from our eyes. A God who wants to pull you close today and hold you and be with you saying, "I have you. I love you." A God who not only feels for Himself, but who comes close to us when we're feeling all our feels, too.

But imagine our relational God creating us in love, to be relational beings, and not giving us all of these emotions.

▶ We'd never feel grateful.
 So we'd never worship God.

▶ We'd never feel mad.
 So we'd never be propelled to take action against injustice.

▶ We'd never feel love.
 So we'd never fall in love or weep at the birth of a child.

▶ We'd never be afraid.
 So we'd never lean into someone for comfort or turn to God for help.

Take away emotions, and we lose all the most intimate and sacred parts of life, the deepest parts of who we are. Would you be who you are without the moments of joy and the seasons of hard?

Would anything mean anything at all?

These emotions can drive us to beautiful choices. God can remake our out-of-control emotions into ones that propel us toward healing and hope. If we choose to stick with Him.

PRACTICAL CHOICES

If we've gotten the big choices out of the way: A) Choose God, and B) Choose honesty, and then to go to Him to be transformed, all the easier said than done. And all choices that will continue to bring life.

After these foundation-forming life choices for our emotions, we may still have more choices on the more practical side that we need to take care of.

Sometimes a feeling that should maybe last for a few days turns into a feeling that lasts a few years, or we find that a certain feeling repeatedly propels us toward unhealthy behaviors. While confession moves us toward healing, there are other decisions that need to be made.

Is there an emotional struggle I feel stuck in?

Do I need counseling?

Do I need to get out of sinful ruts?

Do I need to address hurts haunting me from childhood?

Do I need to heal from circumstances beyond my control?

Do I need to learn new healthy patterns for dealing with my emotional outbursts?

Do we need marriage counseling?

Do I need a new way to do life in a healthier way?

Is it a mood that will pass in a day or two?

Is it a season that will last weeks or months?

Have my emotions turned into a stronghold that is controlling me and I'm no longer in control?

133

Sometimes our emotions are smaller waves. But maybe yours are a riptide that's taking you under and out so far that you really need help.

This part of the process is not black and white. It's a journey of discovering what you are feeling and what you and your community think you need. If noticing, naming, feeling, and sharing have led you and your people to conclude that your emotions are telling you it's time to make a change, there are plenty of ways to make that choice.

Remember our questions to invite Him in?

*God, what do you want **me to know** from this emotion?*
*God, what do you want **me to do**?*

Here are some practical helps that may lead you to make choices that help you heal emotionally. Pray through them with God and see if He leads you to **know or do** something that can untangle another part of your tangled rope.

QUICK CHOICE CHECKUP

> *How's my health physically? Do I need to go to the doctor for a checkup? When's the last time I had full blood panels and hormone panels done, to check if anything bodily could be affecting my moods and emotions?*

> *Am I eating healthy foods and drinking enough water?*

> *How's my sleep? Is there anything I can do to improve?*

> *How's my exercise? Am I moving enough? Am I getting outside in the sunshine enough?*

> *How's my quiet time? Am I giving my brain the physical rest—peace and quiet—that it needs to regulate itself? Do I need to go on a walk or take steps to reclaim quiet space in my life?*

> *Am I logging too much screen time? Is it contributing to loneliness, isolation, or feelings of inferiority?*

> *Am I spending time with people who discourage me and/or contribute to emotional chaos in my life? Do I need to take some space or draw some boundary lines?*

All this may seem basic. But as fully functioning creatures, our physical state affects our mental and emotional states. And our little choices can add up to big differences in our emotional health. So, as you contemplate the big and little choices you want to make as a result of knowing your emotional landscape better, remember: You were made by God. Your emotions were made by God. Your body was made by God. He is constantly compassionate with you, and He wants to help. As you continue to choose Him, He'll keep choosing you.

WHO ARE YOU, LORD? & WHAT DO YOU WANT FROM ME?

Read Psalm 25:5. In light of what you read, answer the questions above.

DIGGING DEEPER

(OPTIONAL PROJECT FOR THOSE OF YOU WANTING TO GO DEEPER)

> *As we've discovered in these weeks together, God feels joy, sadness, anger, fear—all without sin. Because we were made in God's image, that means we have and express emotions. So what will we feel in heaven?*

> *Use an online Bible commentary or app to look up verses in the New Testament describing heaven.*

> *Write a few here and highlight any emotions being felt or expressed. Start with Luke 6:21.*

PROJECT 1
SURRENDER TO GOD

What's the line between experiencing anger and sinning because of it? Or experiencing any emotion and sinning because of it, for that matter?

> *Identify three emotions you've felt this week that you'd rather not have felt, even ones that you reacted to as if they were "wrong." Write them down here:*

1. _____

2. _____

3. _____

> *Pray this prayer:*

Lord, I am honestly feeling the emotion of _____ , and I think it's because _____

[even if you don't know for sure]. I surrender it to You. Please show me how to feel it, how to share it, what to do with it, and what You want me to learn.

PROJECT 2
INVENTORY

At some point, if you've been experiencing an emotion for a while that troubles you, it's time to ask: *Do I need more help with this? Do I need a season of working through this emotion because it has become a stronghold?*

Answer this:

> *How long have you been feeling this emotion? A day, week, month, year, or years?*

Anything more than a year, and, my friend, you need a counselor. There are qualified, licensed professionals to help you get through this. You do *not* need to be ashamed or alone or floundering forever. If financial worries are part of the picture, check with local health clinics, churches, and organizations that offer help. Please, please, don't give up.

HAS MY EMOTION BECOME A STRONGHOLD?

> *How often do I feel this emotion?*

1 ← 2 — 3 — 4 — 5 — 6 — 7 — 8 — 9 → 10

NEVER **ALWAYS**

> *How often have people noticed this being a pattern?*

1 ← 2 — 3 — 4 — 5 — 6 — 7 — 8 — 9 → 10

NEVER **ALWAYS**

> *Do I feel like this emotion is controlling me?*

1 ← 2 — 3 — 4 — 5 — 6 — 7 — 8 — 9 → 10

NEVER **ALWAYS**

> *Do I share this emotion with others?*

1 ← 2 — 3 — 4 — 5 — 6 — 7 — 8 — 9 → 10

NEVER **ALWAYS**

> *Does this emotion keep me from doing things I want to do?*

1 ← 2 — 3 — 4 — 5 — 6 — 7 — 8 — 9 → 10

NEVER **ALWAYS**

> *Has being overwhelmed by this emotion caused me measurable losses?*

1 ← 2 — 3 — 4 — 5 — 6 — 7 — 8 — 9 → 10

NEVER **ALWAYS**

PROJECT 3

BELIEF

What we believe about God affects everything about us, about this journey, and about what we will choose to do with our emotions. Here's a quick refresher to help you identify where you stand, and where you may want to reach out to God and ask for more faith.

> *How confident are you that the story of God is real? Explain your answer.*

> *How confident are you that Jesus is your Savior? Explain your answer and how that confidence or absence of it affects your life.*

> *How confident are you that God has specific purposes for you in His story? For your emotions? What difference has that made for you?*

I'll be honest. I have given my life to God's story, and there are days I wonder if it's all real. It's okay if you waver sometimes. God holds us in place with Him; we don't hold ourselves. Where your faith is weak, pray and ask Him for more. "I do believe; help me overcome by unbelief!" (Mark 9:24 NIV).

PROJECT 4

REFLECT

▷ *In light of everything you've learned in this study, what are you moving toward? What are you leaving behind?*

CONCLUSION

What God is after in your life and mine is relationship. It's proximity. It's intimacy. It's peace. He wants you. He wants me. He wants us to find our relief in Him.

Think back to the disciples, in the boat with Jesus. Learning to trust Him as the waves hit, over and over again. *We're okay,* the disciples finally realized, after they took their fear to Jesus instead.

We're okay. We're okay. Everything will be just fine.

That outcome can be true for us, too. God doesn't ask us to stop being afraid or concerned or frustrated or angry or sad. He simply asks us to stick close by His side.

If I look back at my life and think of my deepest experiences with God, they aren't on the days I felt joy. They are on the days I couldn't get out of my car because of fear. I couldn't show up at work because of tears. I couldn't even speak because I was so mad.

Of course, I want us to fight for joy, because we have . . . a lot to be joyful for.

a lot to be hopeful for.

a lot to be grateful for.

But let's surprise the world and also be sad and angry and scared when it is fitting, not because our God isn't big enough to conquer those things, but because He's big enough to hold those things. Our faith is big enough to hope in the midst of those things.

After going through this journey myself, the new me isn't afraid of emotions. I expect them. They come wave upon wave, sometimes because of a circumstance and sometimes because of my mood. Sometimes just because I'm a human. Today I let those feelings come. I notice them, I form a word around what they are, I let them seep down into all the parts of me because I can be sad and not fall into the darkest pit I've feared all my life. And if it's significant enough, I can tell someone. If it lasts long enough, I decide what I should do about it.

This isn't an organized process, honestly. Even though we just broke it down into six moves. It's the messiest part of life. It's the least likely thing to be controlled.

But the gift I want for you is realizing we don't need to make sense of it all. And we do not need to judge it. We can live in the tension of pain and happiness, all in a given hour. We can laugh and cry all in a given hour. And all that equals a full life that I know none of us would want to miss. Untangled emotions. Connected to others. Connected to God.

"I have told you these things," Jesus said, "so that in me you may have peace. In this world you will have trouble. But take heart! I have overcome the world" (John 16:33 NIV).

SEE ::

Watch video session six: **CHOOSE**
Take notes if you like.

ASK ::

Use session six: **CHOOSE**
Conversation Cards for group discussion.

LEADER'S GUIDE

PHOTO BY: MESHALI MITCHELL

Dear leader,

I am grateful for the chance to equip you in your efforts to disciple others! I pray that these few short pages will help to prepare you to lead this study. You may have led plenty of groups in the past, or perhaps this is the first one. Whichever the case, this is a spiritual calling, and you are entering spiritual places with these participants—and spiritual callings and places need spiritual power.

My husband, Zac, always says, "Changed lives change lives." If you are not first aware of your own need for life change, the people around you won't see their need. If you allow God into the inner struggles of your heart, the people following you will be much more likely to let Him into theirs. Thank you for leading the way.

I've learned that our biggest emotional responses are trying to tell us something important. More than just a race of adrenaline, they're actually pointing the way to something deep-seated in our heart. Something that needs to be brought to the surface. Because your feelings were never meant to be beaten back, stuffed down, or fixed. They were meant to be felt.

This study is my invitation for you to hold your tangled feelings to the light. To allow your full self a seat at the table so that all of you can learn how to live fully, wholly, abundantly again—or maybe for the very first time…

Through these six weeks, together, we'll learn that when we start feeling again, we'll start living again.

This journey invites us to name what we feel, navigating those feelings in a healthy way, and embracing the healing that comes next. I want a life where, instead of ignoring our feelings, we notice them, name them, and let God use them to draw us closer to Himself and others. I want to flip the script on the way we connect with God and others through our emotions. Don't you?

Together, we can do this. We can and we will encourage one another, hold each other accountable, and fix our eyes on Jesus. That is where we will find true freedom. God built us to feel and connect with Him and the people around us through our emotions. Let's take a bold step together toward the emotional health we were meant for.

Grateful,

Jennie

PREPARING YOURSELF TO LEAD

1. Pray

Pray for yourself: Pray that you would be led by the Spirit. Pray that you would lead with wisdom, compassion, discernment, and urgency. Pray fervently and continuously.

Pray for your study participants, that they would:

▶ embrace God's plan for our emotions and feel safe to open up and connect.

▶ have hearts that are teachable and moldable.

▶ be transformed by God's Word and His Spirit.

2. Lean on God

Don't lead this Bible study in your own power. Allow the Holy Spirit to lead every moment—your preparation, your facilitation, your follow-up.

Don't just teach what's on the page. Allow the Spirit freedom to work outside the boundaries of your plan and agenda.

Depend on God for the results. Don't try to manufacture moments or experiences. Keep in mind your responsibility is to be obedient and faithful to teach the Word. The results are left to God.

Teach out of the overflow of your own walk with God. You can't pour out much truth from an empty pitcher. Spend time daily with the Savior in an intimate love relationship with Him. Let Him pour into you before you pour out on others.

3. Be Vulnerable

There will be times you will need to open up and share your life. This will help others feel safe to share. But don't feel like you have to share every detail. You don't. Share what is necessary, guided by the Holy Spirit.

4. Listen, but Also Lead

Allow people to share their struggles and do your best not to interrupt. However, you will need to guide the conversation. You will need to include everyone in the discussion. You will need to continue to steer the conversation back to the truth of God's Word.

5. Model Trust

Don't be a "do as I say" leader. Be the example. Apply what you have learned and are learning through the study.

THE STUDY: SESSION TOOLS AND FORMAT

Untangle Your Emotions is designed to work in various types of venues and locations, including homes, dorm rooms, workplaces, or churches. Whether you find yourself leading a large group of people at church or a few neighbors in your home, the study is designed for small groups to share and process truth. I suggest a maximum number of eight in your group. If you are leading a large group at church, divide into smaller groups and enlist people to lead each small group.

WHAT A LEADER NEEDS

Study Guide. Each study guide comes with leader's guide and streaming video access.

Conversation Card Deck. Group discussion questions and memory verse card for each session.

SESSION TOOLS AND HOW TO USE THEM

STUDY

Every participant will need a Bible study guide. Distribute the books at your first group meeting and walk participants through them. Point out the weekly Study section, followed by the Projects. These can be completed in one sitting or spaced throughout the week. The lessons in the book (except for the Introduction lesson) should be completed between group meetings.

The lessons are interactive, designed to help people study Scripture for themselves and apply it to their lives. The Projects in the Bible study guide will provide creative options for applying Scripture. Some of these experiences may push participants outside their comfort zones. Encourage them to be brave and tackle the challenge. Make sure to discuss the Projects at each group meeting.

SEE

Open each group gathering by reviewing the Study and Projects experiences from the previous week and asking if anyone had anything specific to share or ask about. Watch the short, engaging video teaching to introduce the lesson, set the tone for your time together, and challenge your group to apply Scripture. If your group members want to take notes, encourage them to use the Notes page opposite each SEE title page. Each study guide includes instructions for personal access to streaming video on the inside

front cover. This is perfect for anyone who might miss a group gathering, want to rewatch any of the video teaching, or if your group needs to meet on shortened time.

ASK

After the video teaching is complete, ask the group if anything in particular stood out while you prepare the Conversation Cards. The Conversation Cards provide a unique way to jump-start honest discussion. Each week's cards are labeled with the appropriate lesson title and can be used after the video or teaching time. The following is a suggested step-by-step way to use the cards.

> ▶ Begin by laying out the Scripture Cards for that specific week.

> ▶ Direct each group member to take a card.

> ▶ Go over the Ground Rules each week. (Ground rules are found on page 6 and on the back of the Instruction card.)

> ▶ Take turns presenting the question on each card to the group. Provide adequate time for everyone in your group to respond to each question.

Don't feel pressured to read and answer every card. Be sensitive to the leading of the Holy Spirit and your time constraints. Remind the group that what they share and how they share are entirely personal decisions. No one should be forced to answer every card.

NOTE:
Make use of this leader's guide to facilitate a great Bible study experience for your group. It will help you point people to the overarching theme for each lesson and will give you specific suggestions on how to share the truth and foster discussion.

SESSION FORMAT

This six-session study is designed to go deep very quickly, so it's flexible when considering the length of your group sessions. It can be led in a church spread out over a couple of hours, or in a break room over a one-hour lunch. However, the more time you can allow for discussion, the better. When the group is given deep questions and space to reflect and respond, you'll be surprised by the depth and beauty of the conversations.

You will be the best judge of what time and format works for your group. However, here is a suggested schedule for each group meeting.

1. OPEN—Personal study discussion (15–35 minutes)

After a warm welcome and opening prayer, provide time for the group to share and discuss their personal reflections from the Study of Scripture and the Projects. If you have more than eight in your group, break into smaller groups for this discussion.

2. SEE—Video teaching (17–18 minutes)

Use the video to lay the foundation for the week's lesson and transition to the Conversation Cards. Feel free to provide supplemental teaching for your group.

3. ASK—Conversation Cards (25–75 minutes)

Allow time for each group member to ask and discuss the question on each card. If you need an extra set of cards, they are available for purchase from your favorite online retailer.

4. CLOSE—Closing (5–10 minutes)

Pray as a group and encourage everyone to engage in the Study before meeting again.

TIPS FOR LEADING YOUR GROUP

Always encourage the group members to abide by the following Ground Rules for discussion. These rules can be found below, on the back of the Instruction Card, and on page 6 of this Bible study book.

BE CONCISE

Share your answer to the questions while protecting others' time for sharing. Be considerate. Don't be afraid to share with the group but try not to dominate the conversation.

KEEP GROUP MEMBERS' STORIES CONFIDENTIAL

Your group members will want to share sensitive and personal information with you, not with your husband or other friends. Protect each other by not allowing anything shared in the group to leave the group.

RELY ON SCRIPTURE FOR TRUTH

Conventional, worldly wisdom has value, but it is not absolute truth. Only Scripture provides that. In your times of discussion, be careful not to equate good advice with God's truth.

NO COUNSELING

Work together to protect the group by not directing all attention toward solving one person's problem. This is the place for confessing and discovery and applying truth together as a group. However, at times a member may need to dig even deeper with an outside counselor or talk with a friend outside of small group time. If that is you, don't be afraid to ask for help, or be sure and follow up with a member of the group.

WHEN TO REFER

Some of the people in your group may be dealing with issues beyond your ability to help. If you sense that someone may need more extensive help, refer them to speak with your pastor or a trained Christian counselor. Maintain the relationship and follow up with them to make sure they are getting the care needed. You or someone else in your group may need to walk with them through this season of their life. As we have said many times, be sensitive to the Holy Spirit's leading as you love and offer hope to the people in your group.

TYPES OF LEARNERS

Hopefully, you will be blessed to be leading this study with a group diverse in age, experience, and style. While the benefits of coming together as a diverse group to discuss God outweigh the challenges by a mile, there are often distinctions in learning styles. Just be aware and consider some of the differences in different types of learning styles that may be represented. (These are obviously generalizations, and each person as an individual will express their own unique communication style, but in general these are common characteristics.)

SESSION 1

INTRODUCTION

Note to leader: The teaching format for this session is different than the other sessions because it is the first group time and there is no personal study to review. Participants are encouraged to complete the Introduction material and Projects on page 10–27 on their own to acclimate to the purpose of this study. These pages can be done after viewing and discussing the video or on their own time.

1. OPEN

Welcome the participants to your group and take a few moments for introductions. Briefly share about yourself and allow others to do the same. After introductions, lead the group in prayer.

Distribute the Bible study guides to group members and go over the Instructions and Expectations on page 4. Explain and show them their individual access to streaming video so everyone can keep up with the study, regardless of an unavoidable missed gathering.

2. SEE

View session one video: INTRODUCTION

3. ASK

Transition to the Conversation Cards for discussion. The cards for this week are labeled "Session 1—INTRODUCTION" on the front. Lead participants to choose, answer, and discuss the questions on the cards. (You can review the instructions for using the cards in "SESSION FORMAT" on page 157.)

4. CLOSE

Close by asking the group to write down three things:

▶ one thing they learned from this session;

▶ one reason they are excited about this study;

▶ one question they have moving forward.

Briefly discuss their responses. Do so with little or no commentary but paying close attention to the answers. If time allows, close by praying specifically for each

person in your group, using one of each person's responses as the focus of your prayer for them.

"For we have not an high priest which cannot be touched with the feeling of our infirmities; but was in all points tempted like as we are, yet without sin" (Hebrews 4:15 KJV).

Instruct the group to complete Session 2 Study and Projects before the next group meeting.

SESSION 2

NOTICE

MAIN IDEA: Untangling our complex feelings all starts with noticing: what we're sensing in our feelings, whether we'll admit that those feelings are true for us, and when the emotions we're experiencing first showed themselves in our lives.

In this session we will look at how untangling our emotions begins with noticing what we're feeling. We will intentionally pay attention to the ways emotion affects our physical bodies. We will learn how to stop judging our feelings as we notice them, and we will learn that noticing what we are feeling invites God into this first step in the journey toward healing.

Here are some general goals and thoughts for your time together this week:

1. Identify and define why it is and when it is difficult to pause and notice our feelings.

2. Discover examples of God the Father, God the Son, and God the Spirit all noticing emotion.

3. Discuss the ways God notices and what it teaches us about His character.

MAIN GOAL: *Lead people to an honest evaluation of their emotional state and encourage them to invite God in as they notice what they are feeling.*

1. OPEN

Begin by reviewing the personal study and projects from last week. Here are some suggested places to focus as you review:

▶ What truth stood out to you in the three examples of God noticing His emotions and the emotions of others in the passages you read this week?

▶ How does Matthew 19:14 give you confidence to take the first step in noticing your emotion and bringing it to God?

▶ Share their responses to Project 3.

▶ What else stood out to you from the lesson and Scripture that you want to learn, treasure, and/or apply?

2. SEE

Watch session two video: NOTICE

3. ASK

Transition to the Conversation Cards to continue your discussion. The cards for this week are labeled "Session 2—NOTICE" on the front. Lead the group to choose, answer, and discuss the questions on the cards. (You can review the instructions for using the cards in "SESSION FORMAT" on page 157.)

4. CLOSE

Ask: "What is one thing you noticed in your body this week when experiencing a strong emotion? Was this the first time you noticed this particular reaction?" Encourage group members to choose a partner and share their answers to that question with each other. Then challenge them to pray for each other.

Read this week's Scripture memory verse aloud to the group and tell the group to commit each verse to memory as best they can.

"Would not God discover this? For he knows the secrets of the heart" (Psalm 44:21).

Encourage the group to complete Session 3 Study and Projects before the next group meeting.

SESSION 3

NAME

MAIN IDEA: *There are four main emotions we will focus on together. And for each one, let's discover the other words we can use to move from just saying "sad" to "melancholy" or "disappointed". God meets us exactly where we are and offers us Living Water, or a relationship with Himself, and an invitation to worship the Father in Spirit and in truth.*

Here are some general goals and thoughts for your time together this week:

1. Explore how emotional maturity is the ability to feel what we feel, without judgment or without being controlled by our emotions.

163

2. Gain clarity on what we are actually feeling.

3. Remember that God shares in our joy, our sadness, our anger, our fear.

MAIN GOAL: *Practice naming our feelings instead of evading them. Help people focus on pausing periodically, noticing how they feel, and naming the feeling. Remember together how God the Son, the Father, and the Holy Spirit name what is true and will help you do the same.*

1. OPEN

Begin by reviewing the personal study from last week. Here are some suggested places to focus as you review:

▶ Discuss the story of Jesus weeping over the death of his friend in John 11. What can we learn about Jesus' emotions from this story?

▶ Do you have a complicated relationship with anger, fear, sadness, or joy?

▶ What stood out to you in Romans 8:26–27?

▶ Have the group share their experience this week from Project 4.

▶ What else stood out to you from the lesson and Scripture that you need to learn, treasure, and/or apply?

2. SEE

Watch session three video: NAME

3. ASK

Transition to the Conversation Cards to continue your discussion. The cards for this week are labeled "Session 3—NAME" on the front. Lead the group to choose,

answer, and discuss the questions on the cards. (You can review the instructions for using the cards in "SESSION FORMAT" on page 157.)

4. CLOSE

Invite the group to look at the feelings chart on page 71 and share a word that best describes their current emotional state. Pray for the person to your right after they share.

Read this week's Scripture memory verse aloud to the group and tell the group to commit each verse to memory as best they can.

"Likewise the Spirit helps us in our weakness. For we do not know what to pray for as we ought, but the Spirit himself intercedes for us with groanings too deep for words" (Romans 8:26).

Close with prayer.

Encourage the group to complete Session 4 Study and Projects before the next group meeting.

SESSION 4

FEEL

MAIN IDEA: *Despite what you may have been taught, your emotions are not symptoms of sin or a lack of faith. Your emotions are meant to grow your faith, meant to lead you into deeper relationship with the One who made you and who created the very emotions you feel.*

Here are some general goals and thoughts for your time together this session:

▶ Help the group see the way that the Father, the Holy Spirit, Jesus, are calling us out of avoidance, and into places of joy and connection.

▶ Remember together that you can feel all your feelings and not sin. And you can feel all your feelings and sin. But feeling a feeling in and of itself is not a sin.

▶ Jesus experiencing fear in the garden of Gethsemane can comfort us in our own fear.

▶ God is not distant or judging of our feelings, so we can run to Him for comfort, understanding, and grace.

MAIN GOAL: *Lead people to see feeling their emotions fully as an invitation to be drawn into a deeper relationship with God.*

1. OPEN

Begin by reviewing the personal study from last week.

Here are some suggested places to focus as you review:

▶ Reflect on the verses on page 86. What does God feel toward you?

▶ What did you feel as you read the story of Jesus in Gethsemane in Luke 22?

▶ Which project stood out to you most this session?

▶ What else stood out to you from the lesson and Scripture that you need to learn, treasure, and/or apply?

2. SEE

Watch session four video: FEEL

3. ASK

Transition to the Conversation Cards to continue your discussion. The cards for this week are labeled "Session 4—FEEL" on the front. Lead the group to choose, answer, and discuss the questions on the cards. (You can review the instructions for using the cards in "SESSION FORMAT" on page 157.)

4. CLOSE

Close by sharing a personal story about your own experience truly feeling emotion this week, and how you've been led to not avoid your feelings, but allow them to connect you to God. Ask if any group member is going through a tough time right now. If one or more people indicate this is true in their lives, circle around them and pray for them.

Read this week's Scripture memory verse aloud to the group and tell the group to commit each verse to memory as best they can.

Encourage the group to complete Session 5 Study and Projects before the next group meeting.

"Cast your cares on the LORD and he will sustain you; he will never let the righteous be shaken" (Psalm 55:22 NIV).

SESSION 5

SHARE

MAIN IDEA: *God built us to feel, and we were built to feel together. Whenever you hide from vulnerability to avoid being misunderstood, wronged, rejected, or hurt, you also keep yourself from the good things of compassion, love, and realizing you're not the only one. Sharing brings us connection and healing.*

Here are some general goals and thoughts for your time together this session:

▶ Connect all that we've learned in noticing and naming our emotions and begin to share it with others.

▶ Discover how sharing with others helps heal from emotional pain.

▶ Encourage risk-taking in sharing with others, even if it's awkward.

▶ Learn what to look for in a safe person to share our emotions with.

▶ God designed us to feel, but He also designed us to feel better after we connect with others and with Him.

MAIN GOAL: *Encourage people that it is worth the risk to share what they are feeling with a safe person because it is how God designed us to thrive emotionally.*

1. OPEN

Begin by reviewing the personal study from last week. Here are some suggested places to focus as you review:

▶ Talk about the characteristics of a safe person to be vulnerable with. Which one is most meaningful to you in your own relationships?

▶ Share your Mad Lib from Project 3 with each other.

▶ Discuss the barriers you face in sharing vulnerably with others and pray together for God's help in overcoming them.

▶ What stood out to you from the lesson and Scripture that you need to learn, treasure, and/or apply?

2. SEE

Watch session five video: SHARE

3. ASK

Transition to the Conversation Cards to continue your discussion. The cards for this week are labeled "Session 5—SHARE" on the front. Lead the group to choose, answer, and discuss the questions on the cards. (You can review the instructions for using the cards in "SESSION FORMAT" on page 157.)

4. CLOSE

Challenge each member of your group to pray for connection, such as, "Lord, help me overcome the risk of rejection or misunderstanding to connect with others more deeply." Encourage them to write the prayer in their book or Bible and date it. Emphasize that this is not a prayer to pray lightly. Provide a quiet moment for them to consider this challenge, then close with prayer.

Read this week's Scripture memory verse aloud to the group and tell the group to commit each verse to memory as best they can.

> "Bear one another's burdens, and so fulfill the law of Christ" (Galatians 6:2).

Encourage the group to complete Session 6 Study and Projects before the next group meeting.

SESSION 6

CHOOSE

MAIN IDEA: *Staying close to God is critical if you want to stay on the road to emotional health. Once we notice what we feel, name what we feel, actually feel it and share it, we have to decide what to do with it.*

Here are some general goals and thoughts for your time together this session:

▶ Emotions are essential to the most intimate and sacred parts of life, the deepest parts of who we are.

▶ Focus on the long view: This is a process we will have to repeat moment by moment.

▶ If you don't know what to do, discuss what you need with the group and be brave to ask for help.

▶ We can choose to go through this process with Jesus, for a lifetime, because He cares for you.

MAIN GOAL: *Explore next steps in this process of noticing, naming, and sharing our emotions.*

1. OPEN

 Begin by reviewing the personal study from last week. Here are some suggested places to focus as you review:

 ▶ Pray through the list on page 115 with God and see if He leads you to know or do something that can untangle another part of your tangled rope.

 ▶ Discuss the story about Jesus and the disciples in Matthew 8. What stands out to you about Jesus' response to the disciples?

 ▶ Share the answers to Project 4. What are you leaving behind and what are you moving toward?

 ▶ What are your reactions to Revelations 21:1–5? What is God's ultimate goal?

 ▶ What else stood out to you from the lesson and Scripture that you need to learn, treasure, and/or apply?

2. SEE

 Watch session six video: CHOOSE

3. ASK

 Transition to the Conversation Cards to continue your discussion. The cards for this week are labeled "Session 6—CHOOSE" on the front. Lead the group to choose,

answer, and discuss the questions on the cards. (You can review the instructions for using the cards in "SESSION FORMAT" on page 157.)

4. CLOSE

Share your personal experience you've had in these weeks together. Allow the group to share similar stories. If a member of your group is having difficulty with this idea or facing anxiety about it, take a moment to surround them and pray for them.

Read this week's Scripture memory verse aloud to the group and remind the group to go back through all the memory verses from weeks one through six. Encourage them to keep committing these verses to memory as they continue through these new practices of untangling their emotions—these verses will guide them and lead them well.

"I have told you these things, so that in me you may have peace. In this world you will have trouble. But take heart! I have overcome the world" (John 16:33).

HOW TO FIND GOD

Humanity had a perfect relationship with God until sin entered the world through Adam and Eve. With sin came the certainty of death and eternal separation from God. The penalty had to be paid. But at the same moment that He named the punishment for the first sin, God issued His promise to provide a way for us to return to Him.

Our sin was to be placed on the perfect sacrifice. God would send His own blameless, perfect Son to bear our sin and suffer our deserved fate—to get us back.

Jesus came, fulfilling thousands of years of prophecy, lived a perfect life, and died a gruesome death, satisfying the payment for our sin. Then after three days, He defeated death, rose from the grave, and is now seated with the Father.

Anyone who accepts the blood of Jesus for the forgiveness of their sin can be adopted as a child of God. To each one who believes, God issues His very own Spirit to seal and empower us to live this life for and with Him.

We were made for God, and He gave everything so that our souls could finally and forever find their rest in Him.

If you have never trusted Christ for the forgiveness of your sins, you can do that this moment. Just tell Him you need Him and tell Him you choose to trust Him as your Lord and Savior.

ALSO AVAILABLE FROM JENNIE ALLEN

BUILDING DEEP COMMUNITY IN A LONELY WORLD

This seven-session video study looks at the original community in Genesis and the Trinity to see how God intended for us to live in community all along.

STOPPING THE SPIRAL OF TOXIC THOUGHTS

In *Get Out of Your Head*, a six-session, video-based Bible study, Jennie inspires and equips us to transform our emotions, our outlook, and even our circumstances by taking control of our thoughts.

YOU ARE ENOUGH BECAUSE JESUS IS ENOUGH.

In this 8-session study, Jennie Allen walks through key passages in the Gospel of John that demonstrate how Jesus is enough. We don't have to prove anything because Jesus has proven everything.

IDENTIFY THE THREADS OF YOUR LIFE

In this DVD-based study using the story of Joseph, Jennie explains how his suffering, gifts, story, and relationships fit into the greater story of God—and how your story can do the same.

THE PLACES WE GET STUCK & THE GOD WHO SETS US FREE

Stuck is an eight-session Bible study experience leading women to the invisible struggles that we fight and to the God who has to set us free.

CHASING AFTER THE HEART OF GOD

Chase is a seven-session Bible study experience to discover the heart of God and what it is exactly He wants from us through major events in the life of David and the Psalms.

Visit JennieAllen.com for more info. Available wherever books & Bibles are sold.